A CULINA ~~~ JOURNAL

BY NATHAN GRAY

A DECADE OF TRAVELING FOR
FOOD, COOKING & CULTURE

First edition, published by Grey Heron in 2015.

P.O. Box 94810
Pasadena, CA 91109
626-607-1182
www.thegreyheron.org
greyheronpublishing@gmail.com

Author contact information:
cphotoj@gmail.com
www.aculinaryphotojournal.com

Library of Congress Control Number: 2015945347

FRONT COVER: The sweet flesh of cacao beans attracts a gecko at a chocolate farm in Hawai'i (Big Island).

BACK COVER: Fishmonger stalls in the early morning under a covered section of Rialto Fish Market in Venice, Italy.

My sincere gratitude goes to the old souls, young spirits, and kind hearts in my life and on the road.

INTRODUCTION

My grandmother's kitchen was a treasure trove in the eyes of a child. A bamboo basket of vegetables and fruits — green, red, white and yellow — looked like a watercolor painting yet emanated the scent of the earth. On the stove, a clay pot of chicken soup sprinkled with mysterious herbs and spices slowly simmered to perfection, overwhelming the house with an aroma that drove my hunger to the edge. In a massive iron wok, trout fiercely sizzled in hot oil; in an instant a splash of crimson sauce would go in and the fish would be ready for me to devour. All the produce was harvested from the countryside by morning light; animals were killed and cleaned in a butcher shop only when an order was placed; eggs laid just hours ago were still warm when held. A morning trip to the market being her daily ritual, my grandmother never dreamed of having a refrigerator before her grandchildren started demanding ice cream.

I never realized the good fortune of growing up with a Chinese grandmother in Beijing until I embarked upon my single adult life in America. With limited culinary skills, I was surviving on takeout pizza and snack cakes from a nearby pharmacy. Then, I met Nathan Gray. A new world opened up. Nathan had been cooking, traveling, and researching various food cultures for years. He introduced my palate to Ethiopian, Persian and Mexican food, and the countless other cuisines hiding in plain sight. Suddenly, American food was no longer just hot dogs and burgers, but a diverse mixture of cultures from around the world. To me, *hanging out with Nathan* equals *tasty food.*

When I began joining Nathan on his travels, I found his focus a bit... odd. While I exhausted my memory card on paintings and sculptures by old masters, he constantly pointed his camera at a colorful fruit stand on the side of the road, a bakery window lit by the rising sun, or a snack stall stealthily parked in an alley. As I was happily spending my days in a museum or at a historic site, he would disappear for hours at a time on his own adventures. In Venice, rising at first light, he found his way to the fish market to catch the fishmongers stocking their stalls. In Turkey, a search for a cup of traditional Turkish coffee led to a tiny hole-in-the-wall in the old city, where locals eyed him with suspicion. In Spain, he took a six-hour detour driving through the mountains of Andalucía, looking for a tiny hidden village said to be

the origin of Spanish ham cured from acorn-fed black pigs. In China, rambling across town, he explored community wet markets where, being the only foreigner for miles, his appearance mildly entertained the vendors and market goers.

Nathan was tenacious. Everywhere we traveled, he had to know everything about the food – the history, the tradition, the origin of the ingredients, and why things are made the way they are. He posed so many questions in a combination of hastily learned local dialects, hand gestures, English and smartphone translators that the proprietors were either astonished by the extent of his knowledge or puzzled by these peculiar inquiries from what they viewed as nothing more than a tourist. Time and again, he dragged me out of my comfort zone into unknown territories. After hours of zigzagging, we arrived at a neighborhood restaurant, often a well-kept secret from outsiders, the food delicious beyond my wildest dreams. Nathan would enthusiastically explain in detail about the dishes, like a child showing off his trophies. Pretending to listen, I focused all my mind and energy on getting to that last bite before he noticed, to avoid any possibility of sharing.

After a decade of traveling, Nathan in his modest way put together this little book of personal favorites from his enormous collection of photographs, each offering a glimpse of the food culture of a country and its inhabitants, from a street vendor preparing a local delicacy in India, to a gecko unable to resist the sweet scent of cacao beans in Hawaii. It is a sample of what he, as a culinary enthusiast, finds most intriguing and informative. However, it touches me on a more fundamental level: It makes me hungry.

— *Heron Qian*

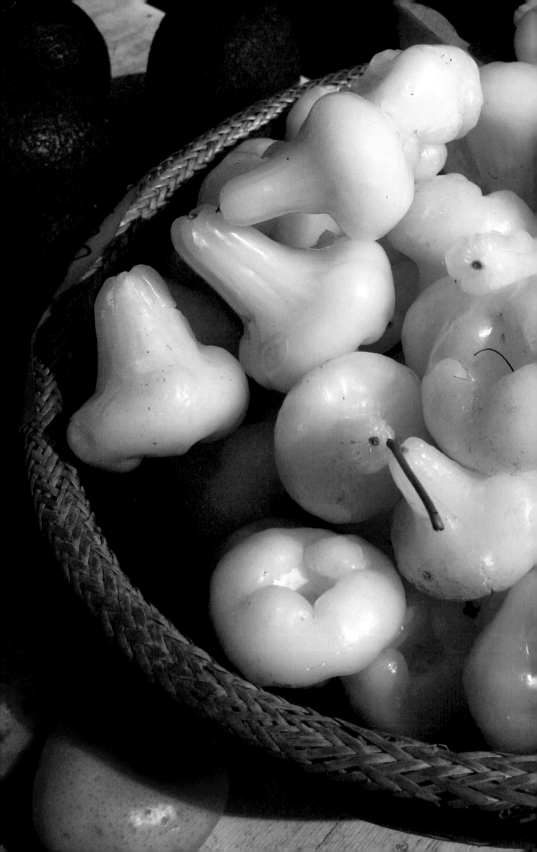

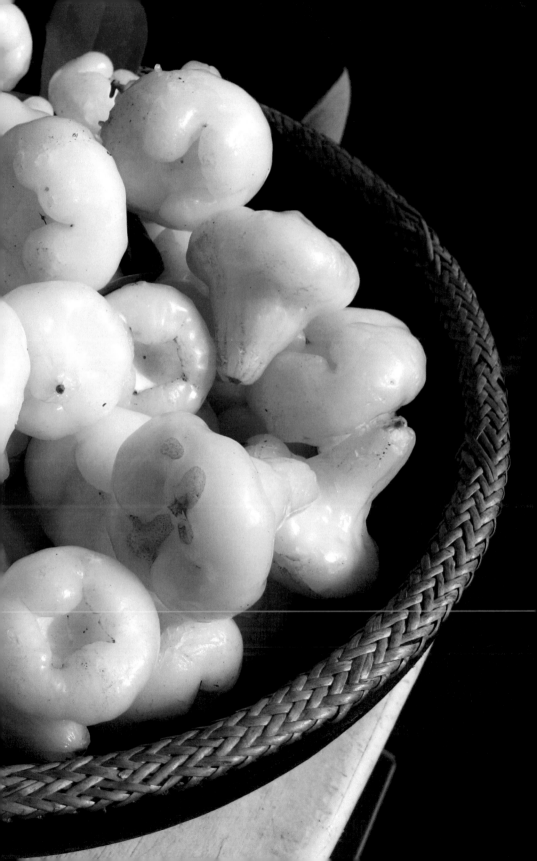

Saddled sea bream fish in Athens, Greece

Saddled sea bream (*Oblada melanura*) or *melanouria* (ΜΕΛΑΝΟΥΡΙΑ), a prized local fish at the Central Market.

< **Previous:**

White mountain apples on the island of Kauai, Hawaii

White mountain apples at the Kauaʻi Community Farmers' Market, fruit of the *Syzygium malaccense*, a.k.a. Malay apples.

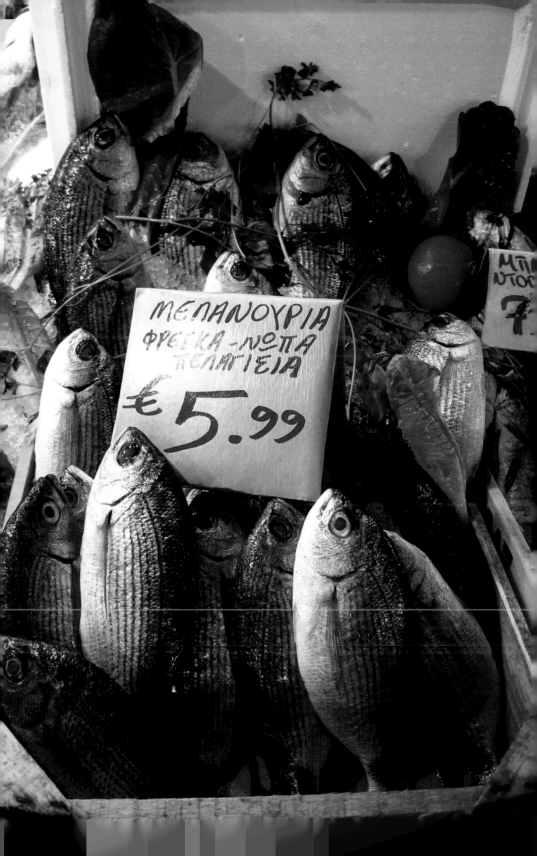

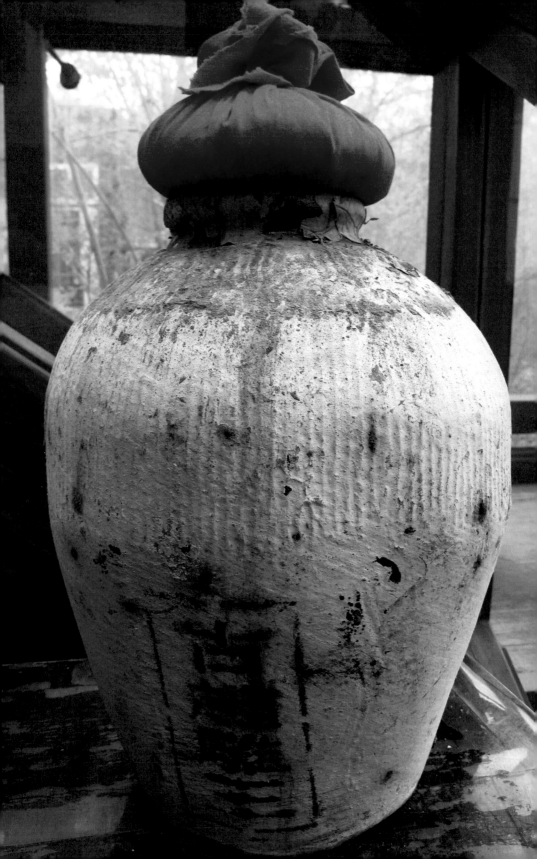

"Old duck soup" in Beijing, China

Lao ya tang (老鸭汤), a milky white duck bone soup that has simmered on the stove for hours, served in individual ceramic containers at restaurant Lanxi Xiao Guan (兰溪小馆).

< Previous:

Clay jars of Chinese rice wine in Beijing, China

Clay jars of aged Shaoxing rice wine (紹興酒), a traditional type of *huangjiu* (黄酒) from Shaoxing, Zhejiang Province.

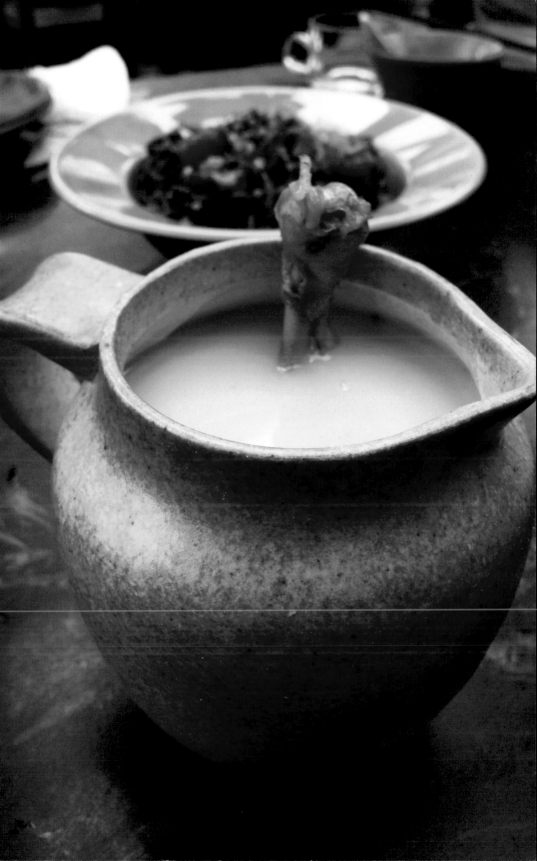

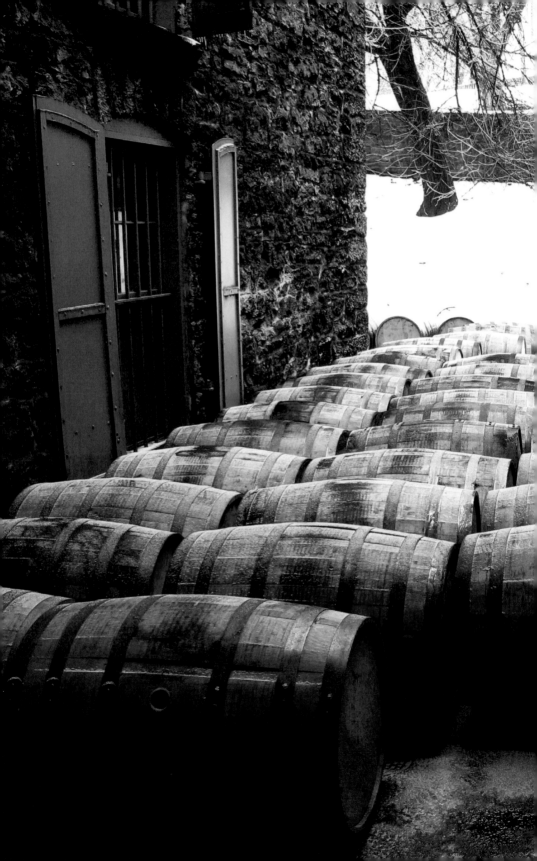

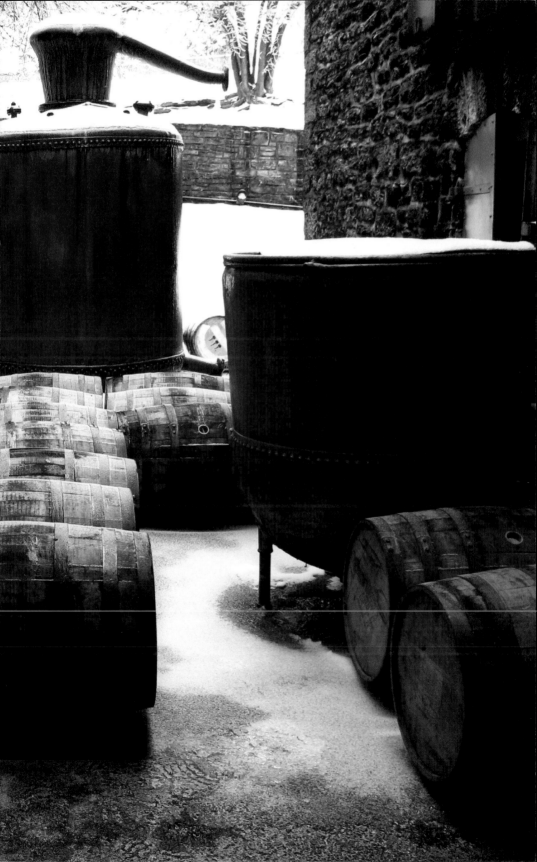

A vendor selling sweets in Old Delhi, India

A man cooks *jalebi* (जलेबी), fried batter sweets similar to funnel cake, on the streets of Old Delhi near Chandni Chowk.

< Previous:

Bourbon barrels at a distillery in Versailles, Kentucky

Rows of emptied Bourbon barrels in the snow at the Woodford Reserve Bourbon Distillery in Versailles, Woodford County.

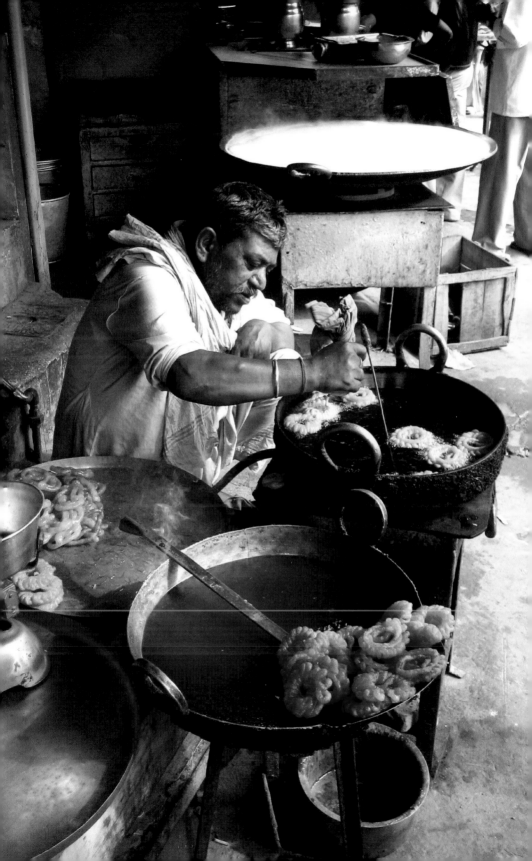

A specialty miso shop in Takayama, Japan

A shop selling many varieties of fermented soy bean paste
(miso or みそ) near the morning market along Miyagawa river.

A Korean BBQ joint in the suburbs of Tokyo, Japan

A restaurant in suburban Tokyo specializing in *bulgogi* (불고기),
a type of Korean BBQ known in Japan as *purukogi* (プルコギ).

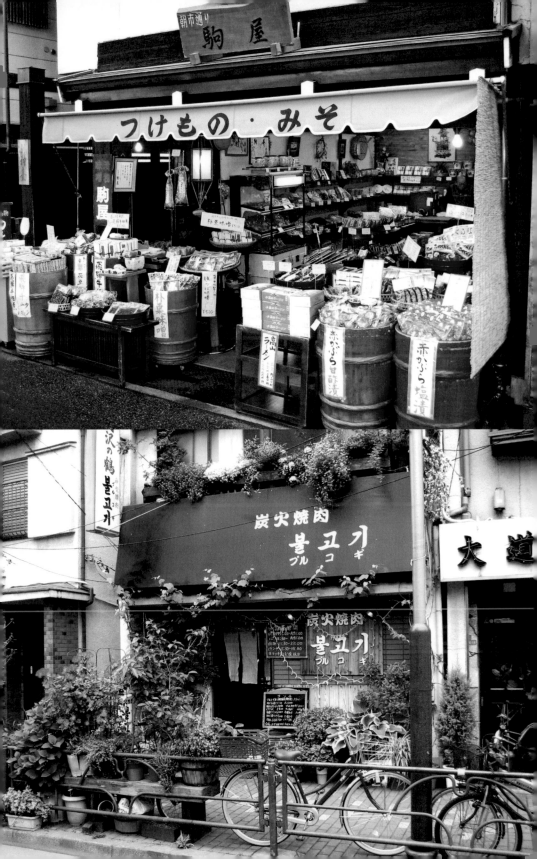

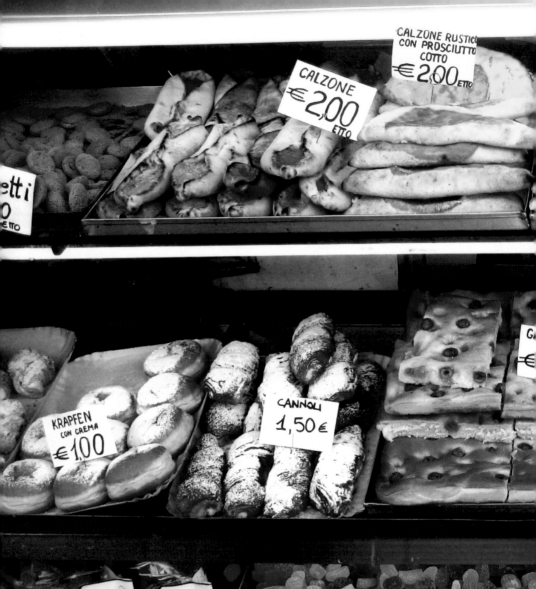

CALZONE RUSTICO
CON PROSCIUTTO
COTTO
€ 2,00 ETTO

CALZONE
€ 2,00 ETTO

etti
0
ETTO

KRAPFEN
CON CREMA
€ 1,00

CANNOLI
1,50 €

G
€

GELATIN
FRUT
2,

SAPO
PANFOR
€ 3,0

€ 4,50

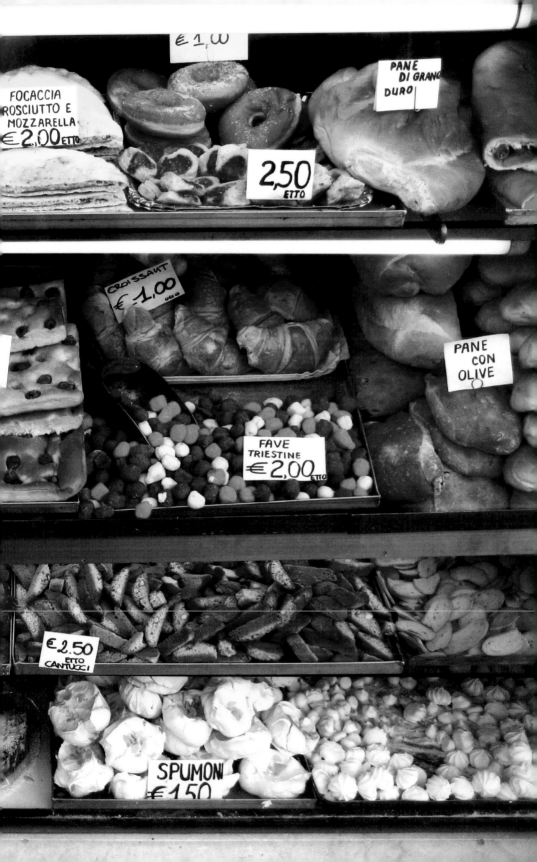

A Greek sesame bread vendor in Athens, Greece

A street vendor selling Greek sesame bread known as *koulouri* (ΚΟΥΛΟΥΡΙ) for breakfast near a metro station.

< Previous:

A bakery window in Venice, Italy

A bakery displays *Focaccia alla Genovese* (olive oil flat bread), *Fave Triestine* (sweet "beans" made of almond paste), *krapfen* (Venetian donuts) and Sicilian *cannoli,* among other things.

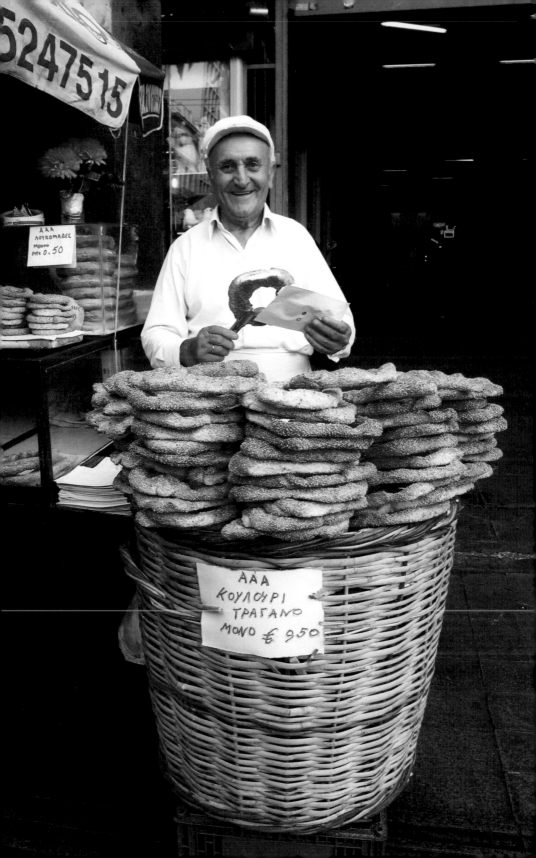

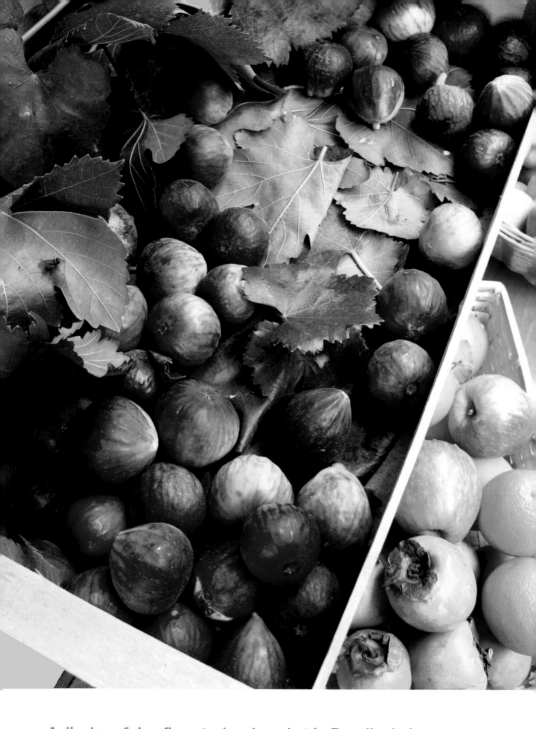

A display of ripe figs at a local market in Ravello, Italy

A box of figs (*fichi*) on a bed of fig leaves for sale at a local market in the mountain town of Ravello on the Amalfi Coast.

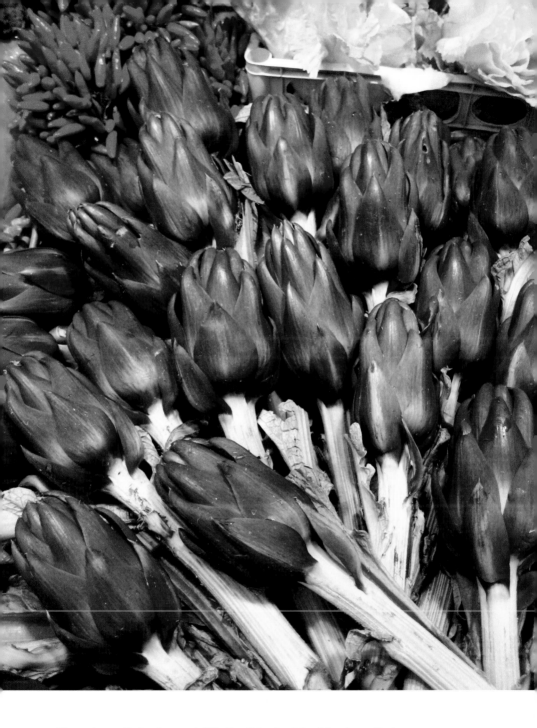

Purple artichokes at Rialto Market in Venice, Italy

Venetian *carciofi violetto* (purple artichokes) and *peperoncino rosso* (red chile peppers), local specialties at Rialto Market.

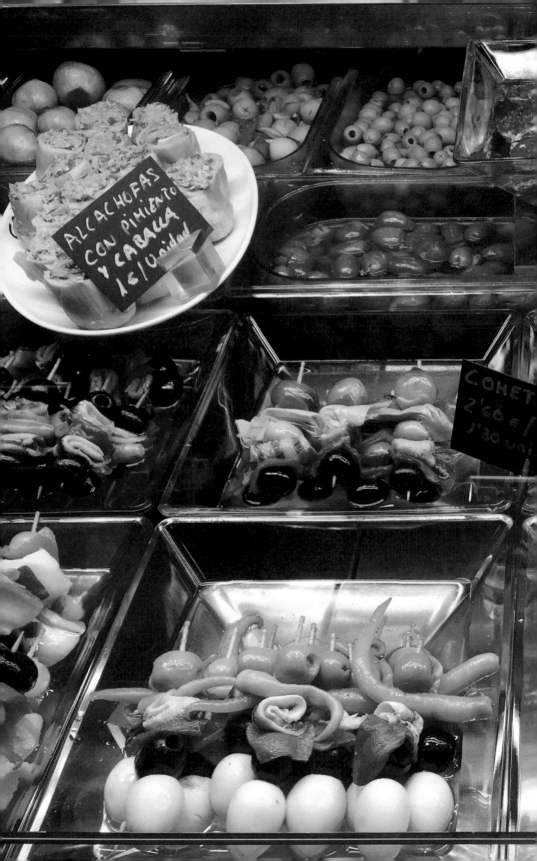

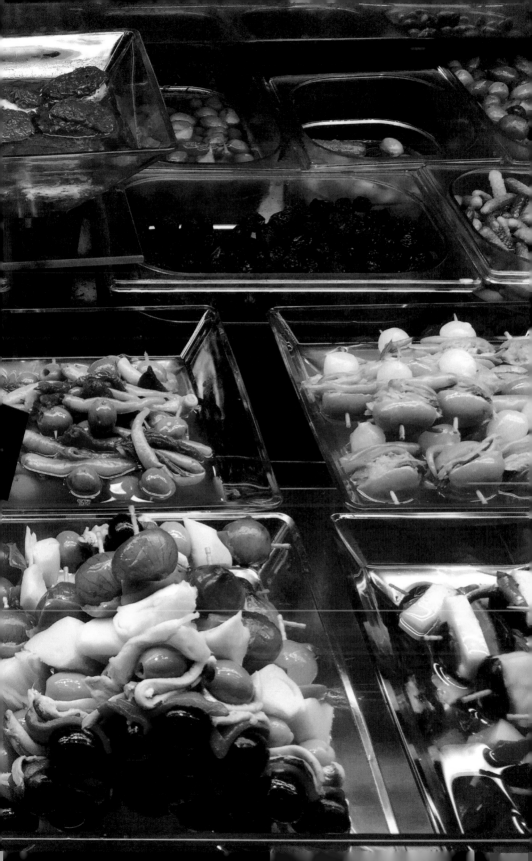

Whole Iberian ham in Jabugo, Spain

Jamón Ibérico de Bellota and *Paleta Ibérica,* cured Iberian ham made from acorn-fed black pigs by producers Sánchez Romero Carvajal and Cinco Jotas (5J) in the birthplace of Iberian ham.

< Previous:

Pickled snacks on skewers in Granada, Spain

Pinchos or *pintxos* (snacks on skewers), such as *cohetes* (rockets) made of quail eggs, anchovies, olives and peppers; and *bombas* (bombs), split olives stuffed in various ways.

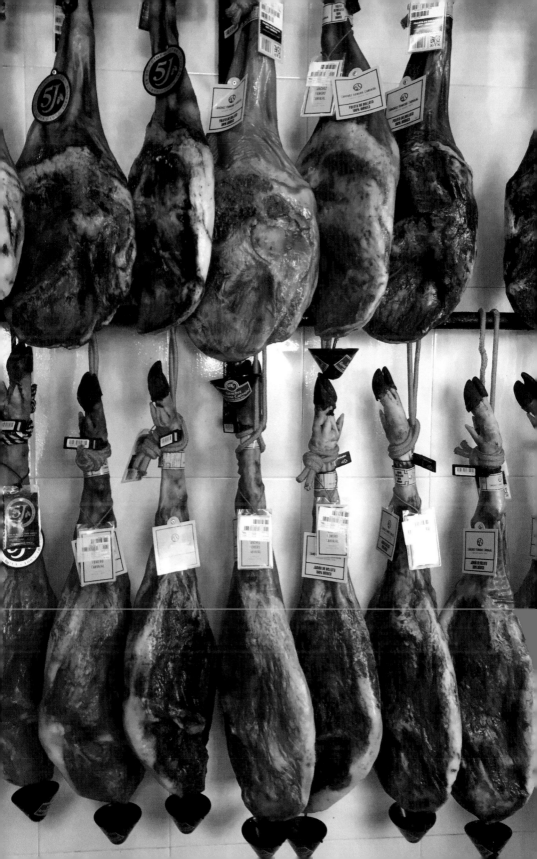

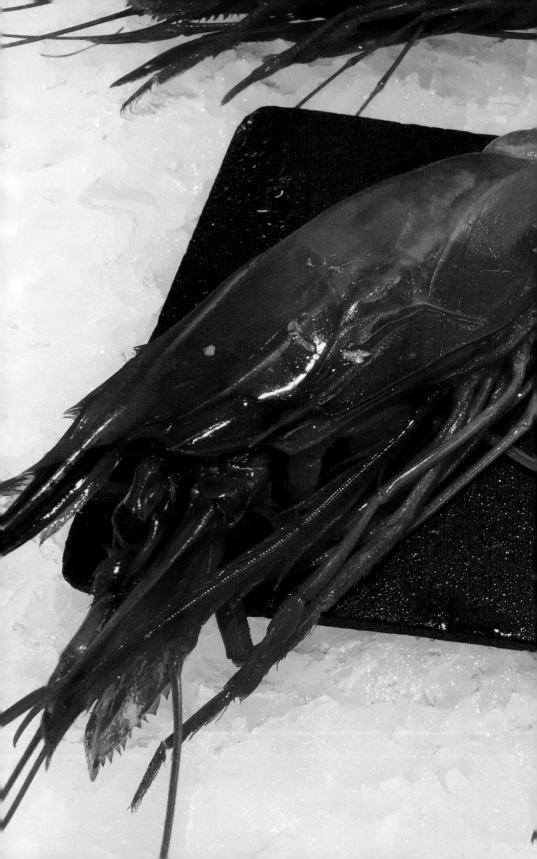

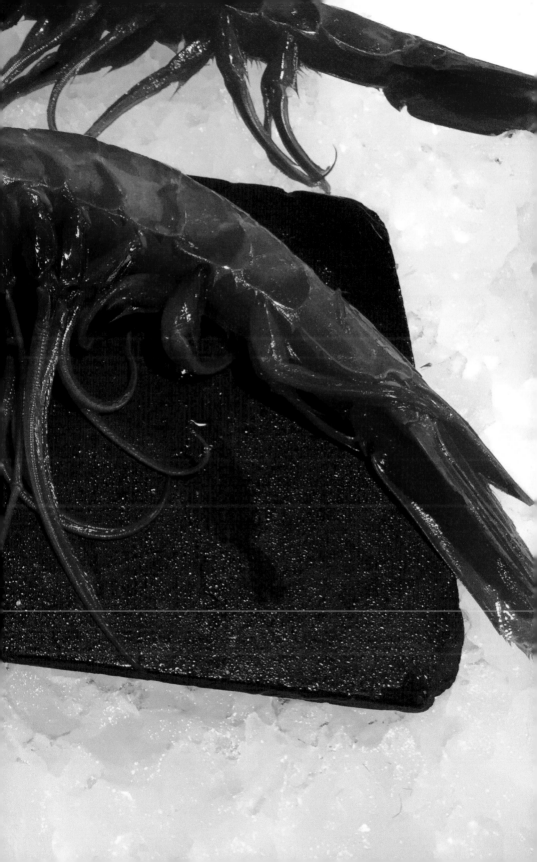

Meat pies at Borough Market in London, England

A variety of hand-made meat pies; fillings include chicken & leek, steak in gravy, and game (venison, pheasant, rabbit, pigeon) at Mrs King's Pies at Borough Market in Southwark.

< Previous:

Large scarlet prawns in Madrid, Spain

Treasured large red prawns from Huelva province known as *Carabinero de Huelva,* on ice at El Señor Martín, a seafood stand in the central market of Madrid, Mercado de San Miguel.

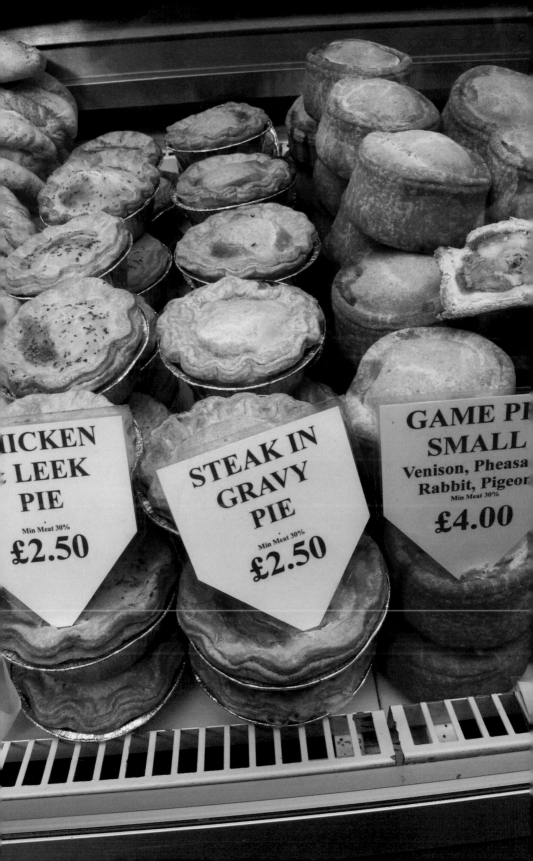

ICKEN LEEK PIE

Min Meat 30%

£2.50

STEAK IN GRAVY PIE

Min Meat 30%

£2.50

GAME PI SMALL

Venison, Pheasa
Rabbit, Pigeon

Min Meat 30%

£4.00

Local pastries in Amalfi, Italy

Pastries including s*fogliatella* (shell pastries), *pasticciotto* (custard filled pies) and *delizia al limone* (lemon delight) at Pasticceria Andrea Pansa, a pastry shop opened since 1830.

Raspberry tart and croissant in Brussels, Belgium

Tarte aux framboises (raspberry tart) and a mini butter croissant at a small local bakery (*boulangerie / patisserie*) in Etterbeek.

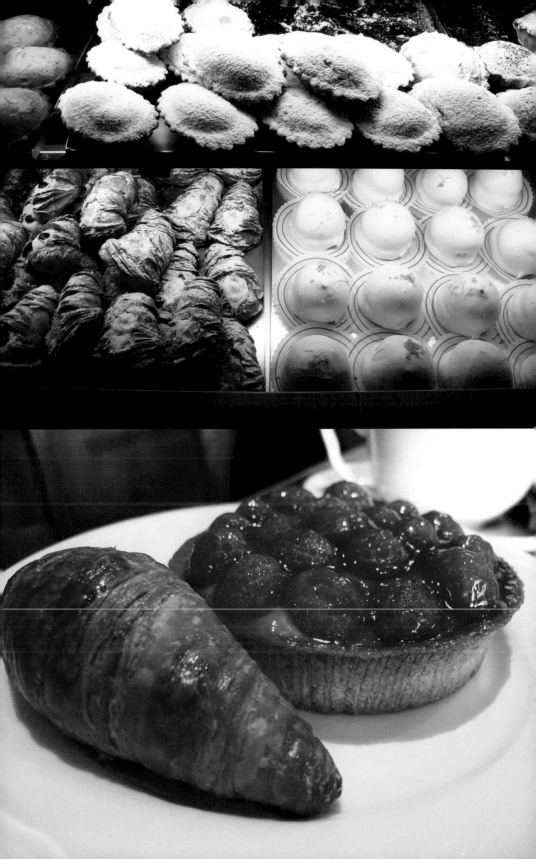

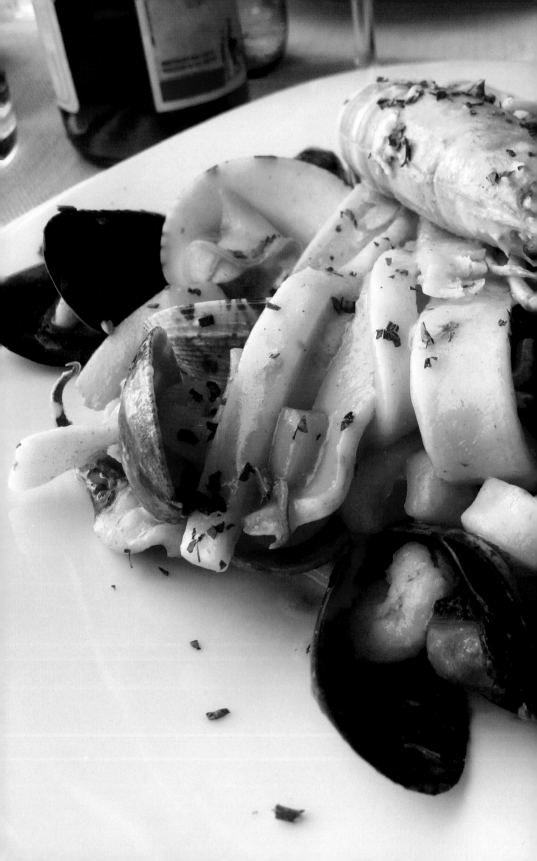

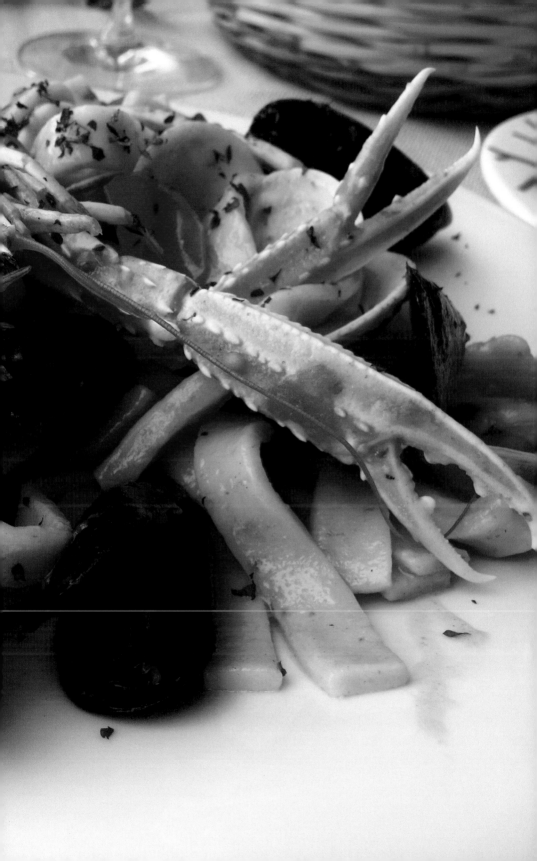

Red pickled octopus in Tokyo, Japan

Red pickled octopus (*tako* or タコ) on ice at Tsukiji Fish Market (築地市場) in Tsukiji district, the largest fish market in the world.

< Previous:

Seafood pasta in Positano, Italy

Scialatielli pasta with local clams (*vongole veraci*), mussels (*cozze*) and a langoustine (*scampo*) at restaurant Buca di Bacco.

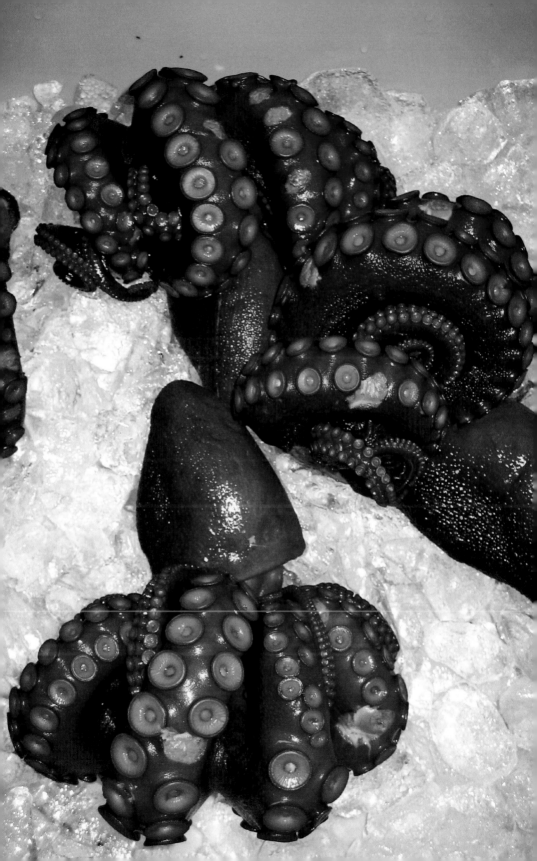

A vegetable street vendor in Delhi, India

A street vendor carries an array of fresh vegetables on a three-wheel cart; among the items:

- tomato — *tamatar* (टमाटर)
- eggplant — *baigan* (बैंगन)
- turnip — *shalajam* (शलजम)
- carrot — *gajar* (गाजर)
- bell peppers or capsicum — *simla mirch* (शिमला मिर्च)
- cabbage — *bandh gobhi* (बंद गोभी)
- cauliflower — *phul gobhi* (फूल गोभी)
- spring onion or scallion — *hari pyaz* (हरी प्याज)
- dill — *soa* (सोआ)
- okra — *bhindi* (भिण्डी)
- mango — *aam* (आम)
- bitter melon — *karela* (करेला)
- bottle gourd — *lauki* (लौकी)

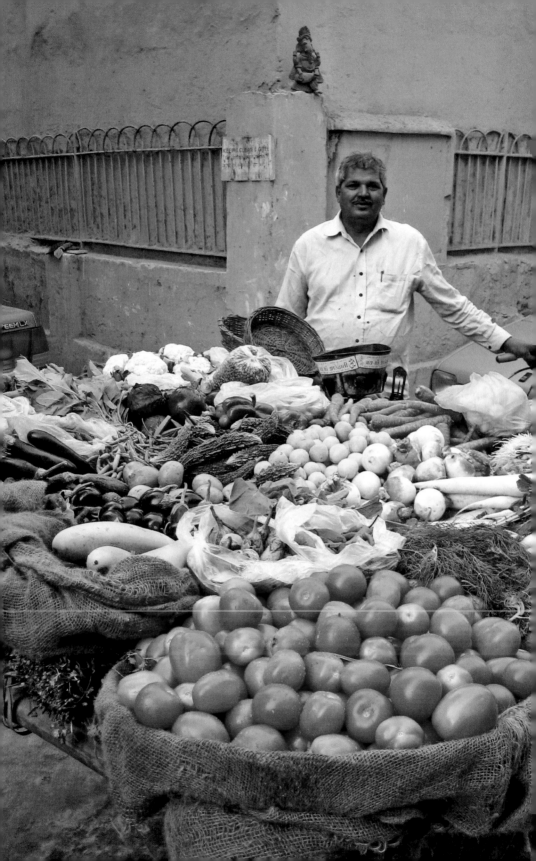

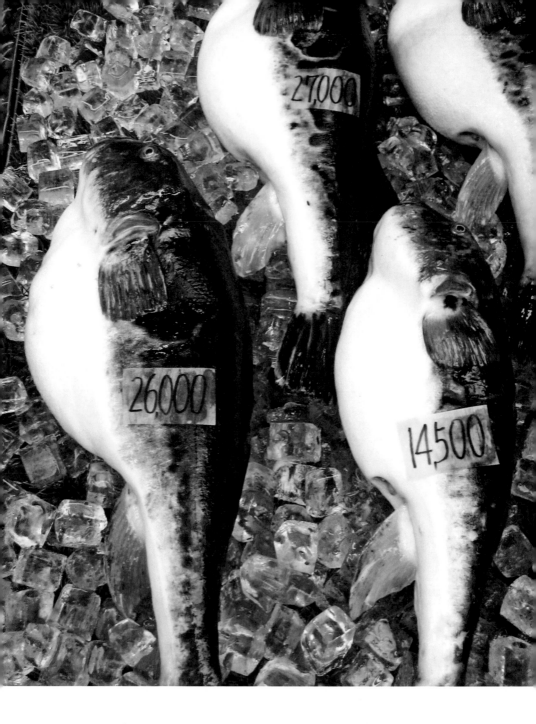

Lethally poisonous puffer fish in Osaka, Japan

Whole *fugu* (フグ) at market Kuromon Ichiba (黒門市場) sold
for up to 27,000 yen / $270 per fish, served sliced as sashimi.

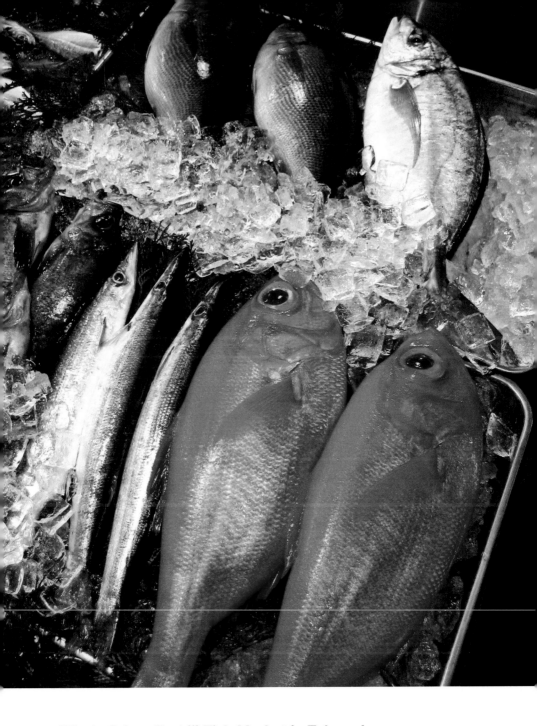

Whole fish at Tsukiji Fish Market in Tokyo, Japan

Saury (*sanma* or サンマ), striped jack (*shima aji* or シマアジ) &
golden eye snapper (*kinmedai* or キンメダイ) on ice at Tsukiji.

Shandong-style giant egg pancake in Beijing, China

A giant egg pancake (大煎饼) stall known as Shandong Sha Da Culiang Jianbing (山东傻大粗粮煎饼), makes the over-sized Chinese egg pancakes on a hot spinning griddle.

< Previous:

Whole country ham in Finchville, Kentucky

Rows of country ham for sale at Finchville Farms Country Ham, a rural store in Shelby County that has been producing ham by traditional salt-curing and drying methods since 1947.

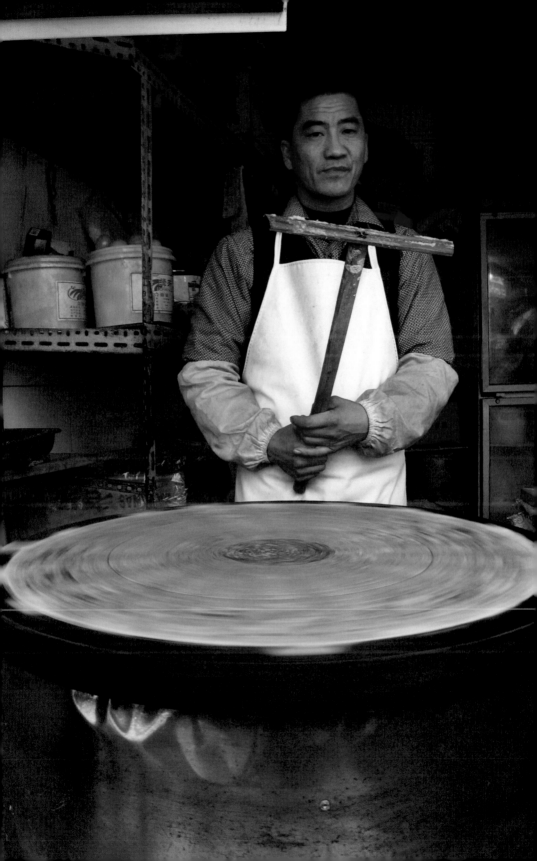

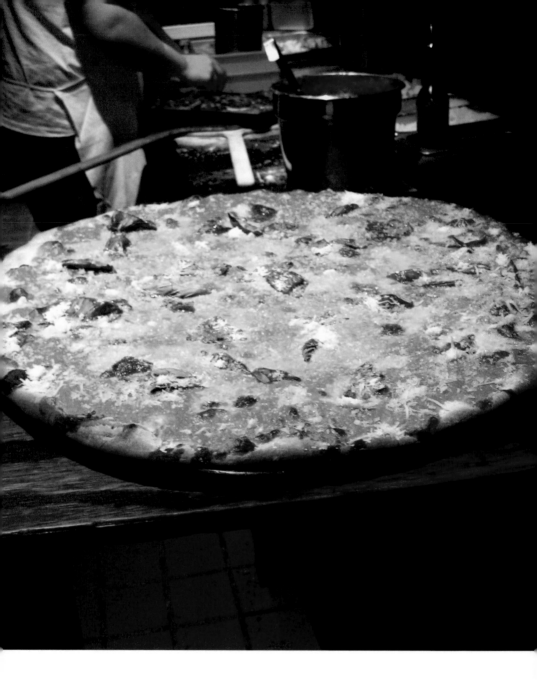

New York-style pizza in Manhattan, New York

A large Pizza Margherita fresh from the oven of Artichoke Basille's Pizza on East 14th Street in Manhattan.

Turkish savory pastries in Kusadasi, Turkey

Two different types of *börek* (stuffed savory pastries), one with minced meat filling and the other cheese and vegetables.

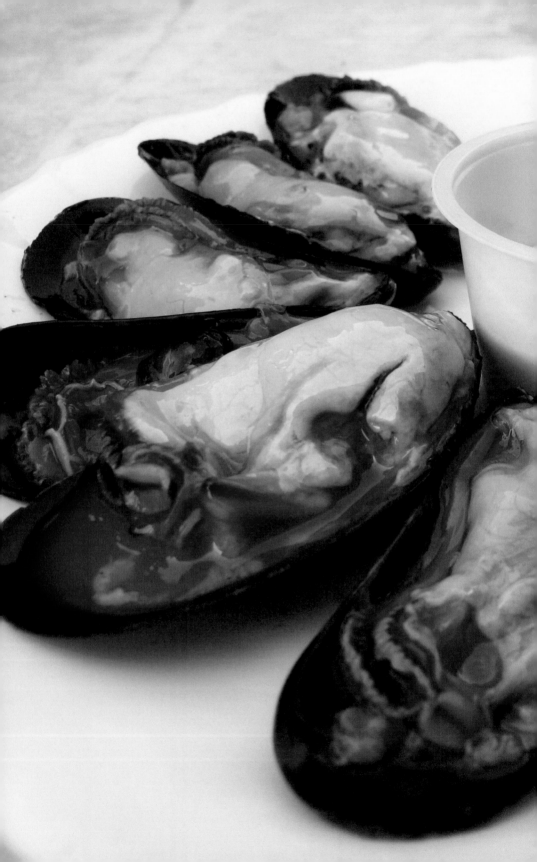

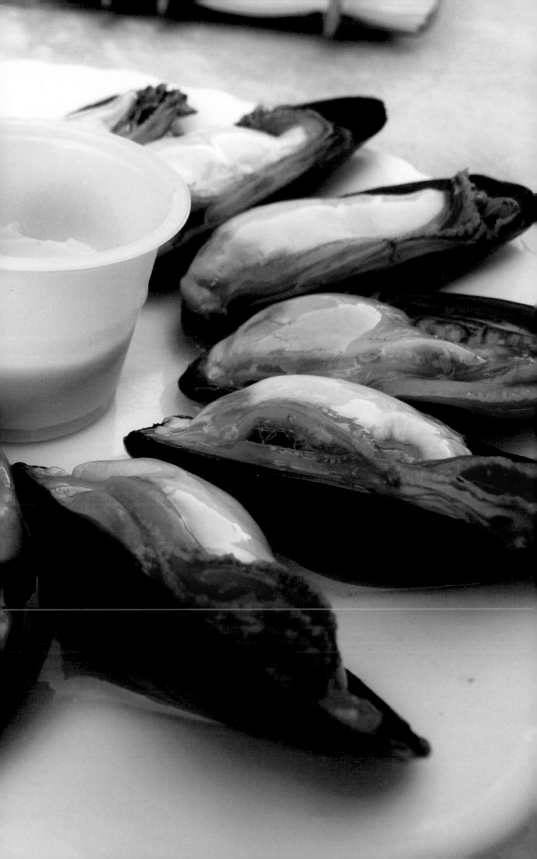

Scallops on ice in Beijing, China

A young fishmonger stacks scallops (*shanbei* or 扇贝) at Sanyuanli Market (三源里市场) in the Chaoyang District.

< **Previous:**

Raw mussels at a street vendor in Brussels, Belgium

Raw mussels (*moules parquées*) served with a mustard based sauce at a roaming street stand known as Chez Marc.

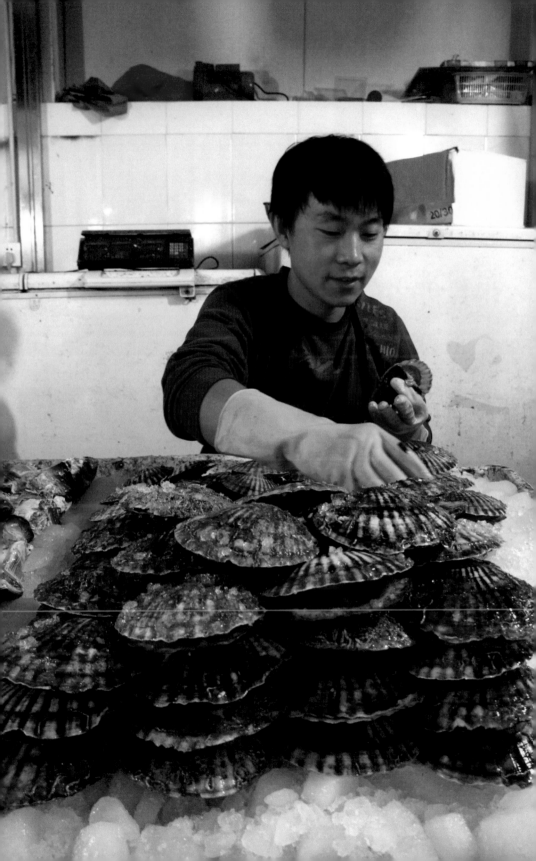

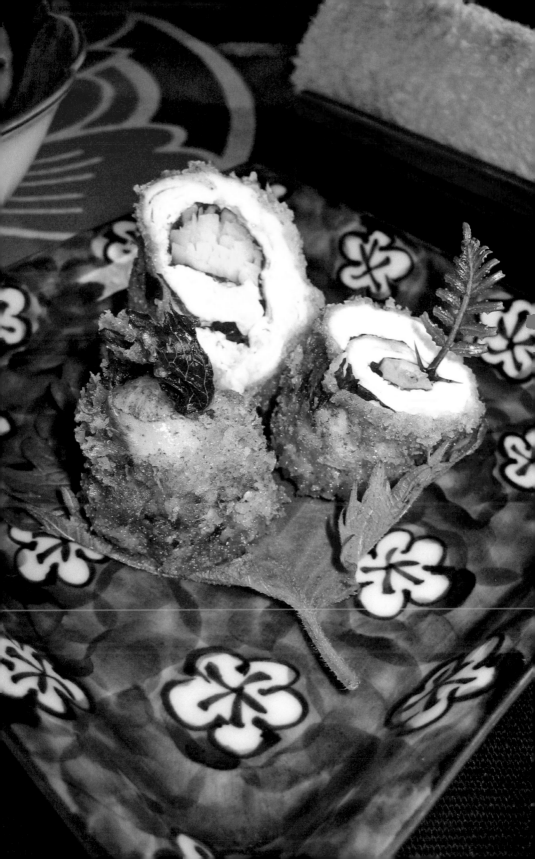

A cooking class in the village of Madhogarh, India

The local *Maharani* and her assistant teach a cooking class at Fort Madhogarh in Rajasthan, explaining the ingredients and *masalas* (spice mixtures) used in Rajasthani cuisine.

< **Previous:**

Fried chicken rolls at a cooking class in Tokyo, Japan

Torikatsu (チキンカツ) stuffed with *shiso* (シソ) leaves, plum paste and ginger at a cooking class with chef Kiyoko Konishi; the table is set in her living room for lunch after the lesson.

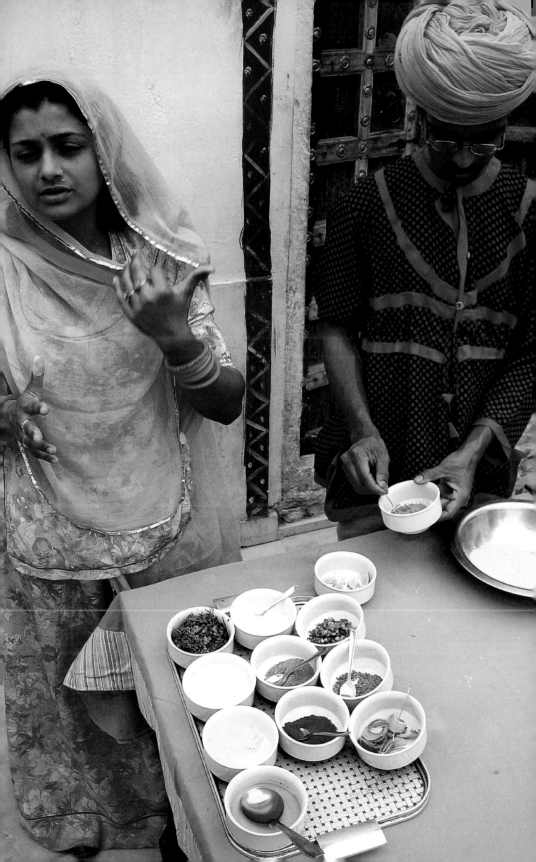

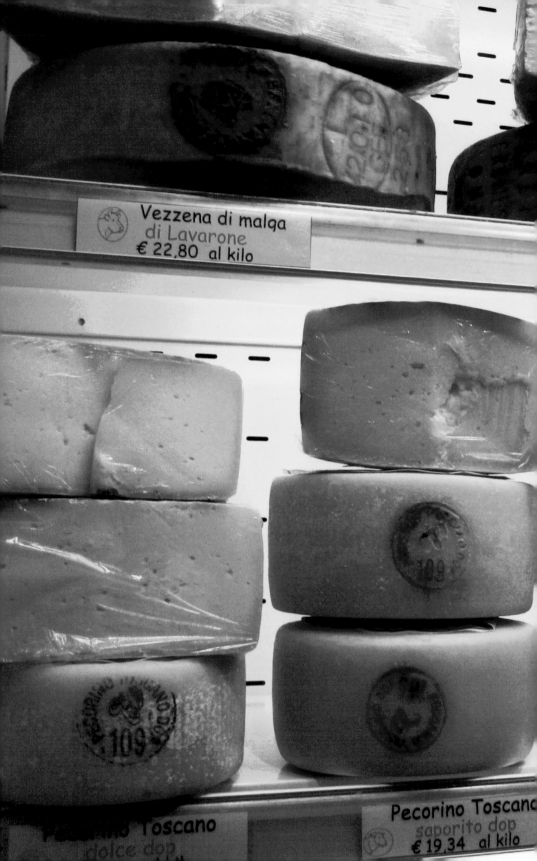

Vezzena di malga
di Lavarone
€ 22,80 al kilo

Pecorino Toscano
dolce dop

Pecorino Toscano
saporito dop
€ 19,34 al kilo

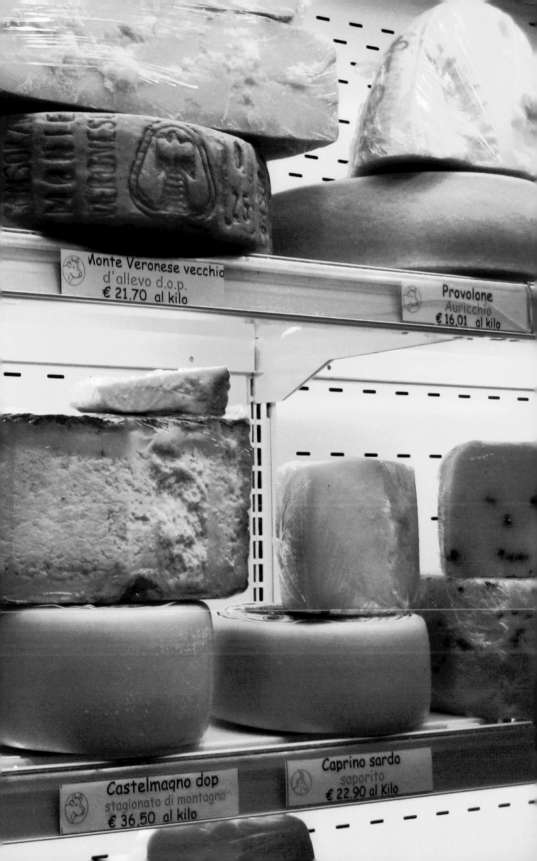

Monte Veronese vecchio
d'allevo d.o.p.
€ 21,70 al kilo

Provolone
Auricchio
€ 16,01 al kilo

Castelmagno dop
stagionato di montagna
€ 36,50 al kilo

Caprino sardo
saporito
€ 22,90 al Kilo

Turkish bread street vendor in Kusadasi, Turkey

A street vendor selling circular sesame bread known as *simit.*

< **Previous:**

A cheese shop in Venice, Italy

A local cheese shop displays wheels of *Vezzena di Malga*, *Monte Veronese*, *Provolone*, *Pecorino Toscano*, *Castelmagno* and *Caprino Sardo*, just a few among its wide selection.

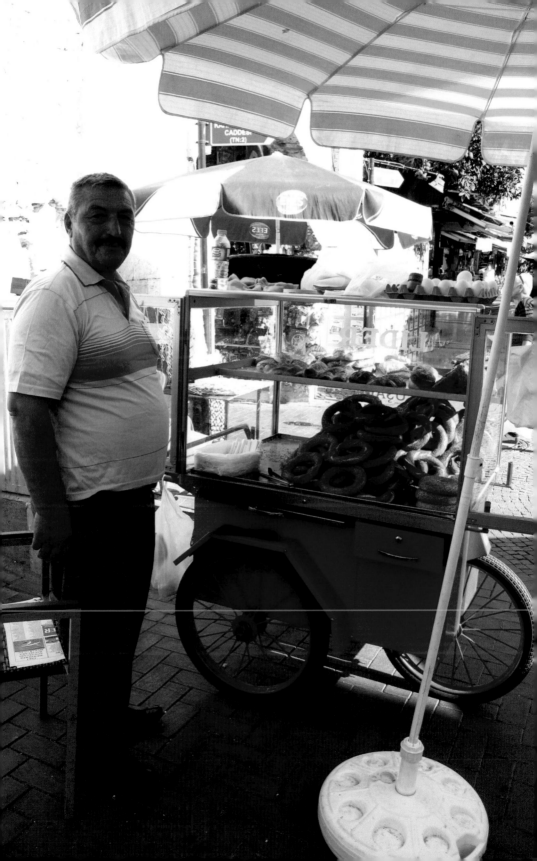

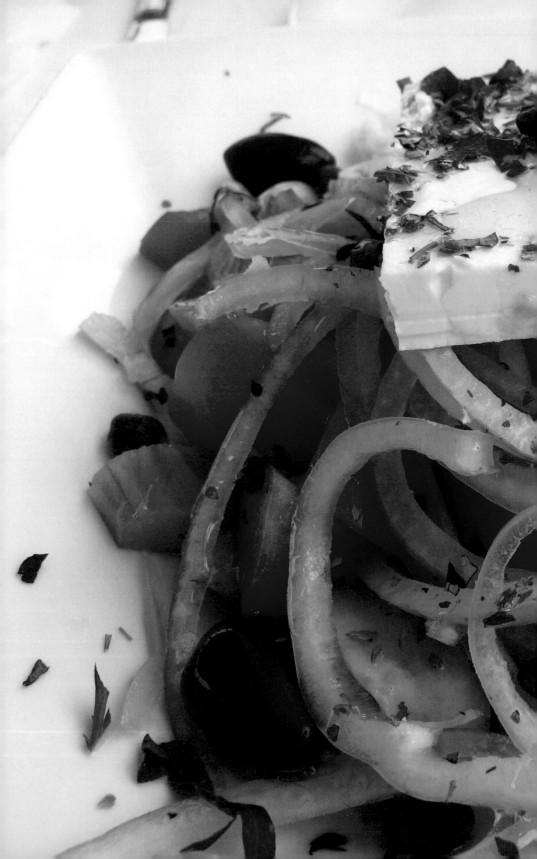

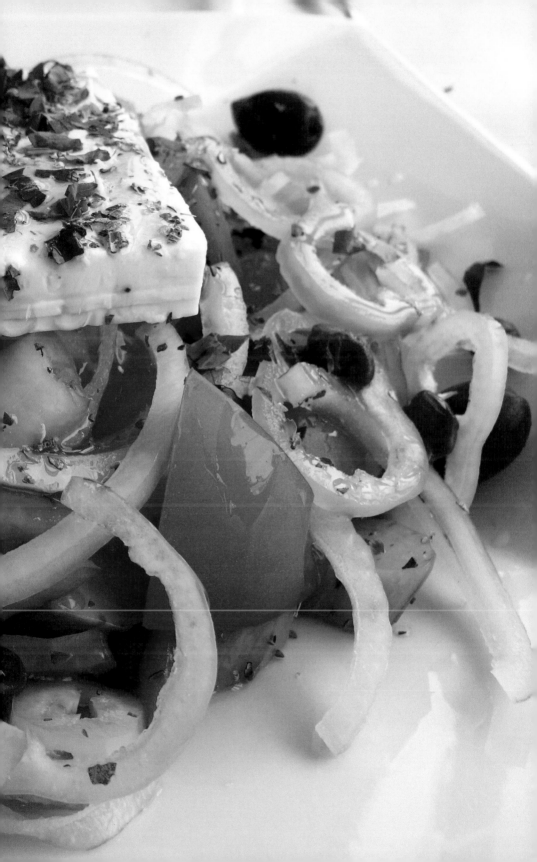

Taberna Alhambra tapas bar in Madrid, Spain

Taberna Alhambra tapas bar founded in 1929, serving traditional Spanish food from around the region.

< Previous:

Greek salad on the island of Santorini, Greece

A classic Greek salad (Χωριάτικη σαλάτα) with tomatoes, onions, green peppers, olives, capers, fennel, cucumbers, feta cheese, olive oil and oregano at restaurant Naoussa.

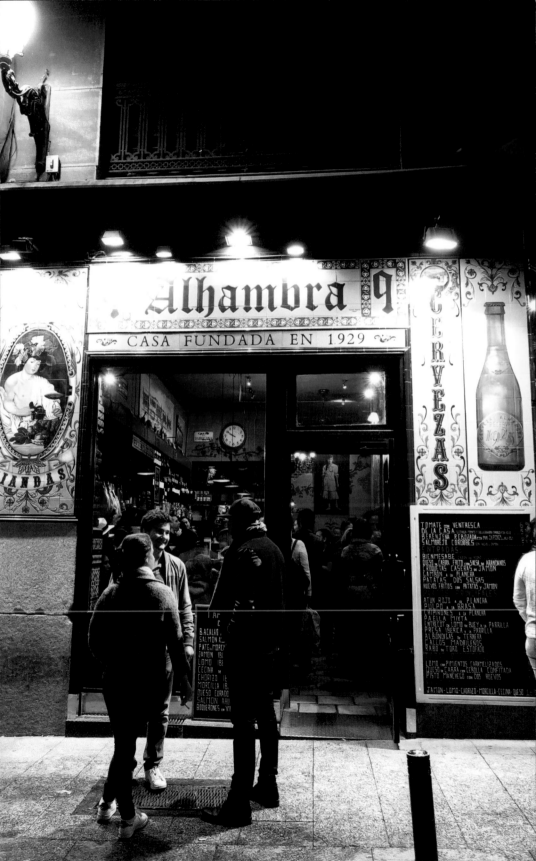

A plate of grilled red shrimp in Cordoba, Spain

Grilled *gambas rojas de Garrucha,* a type of red shrimp from
Garrucha, a coastal town to the east of Córdoba.

A plate of grilled squid in Granada, Spain

Calamar a la plancha (grilled squid) paired with tomatoes at Bar
Los Diamantes, a local seafood tapas bar near Plaza Nueva.

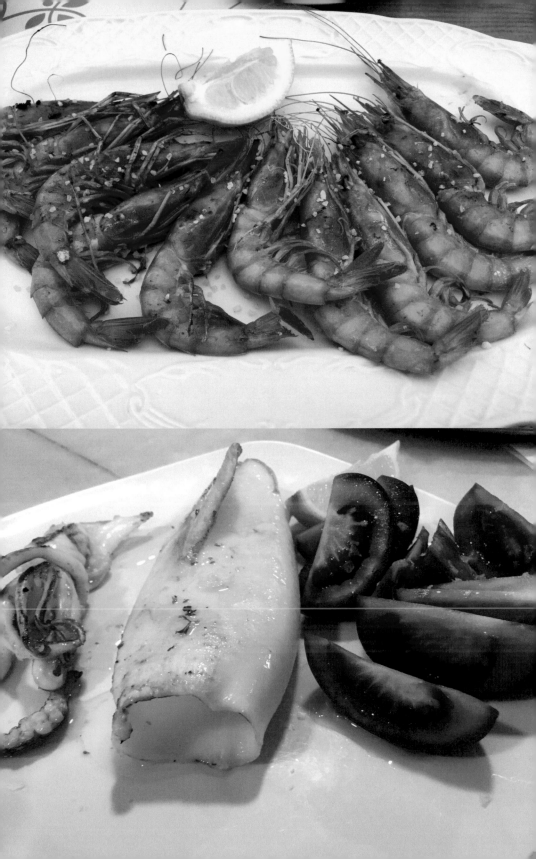

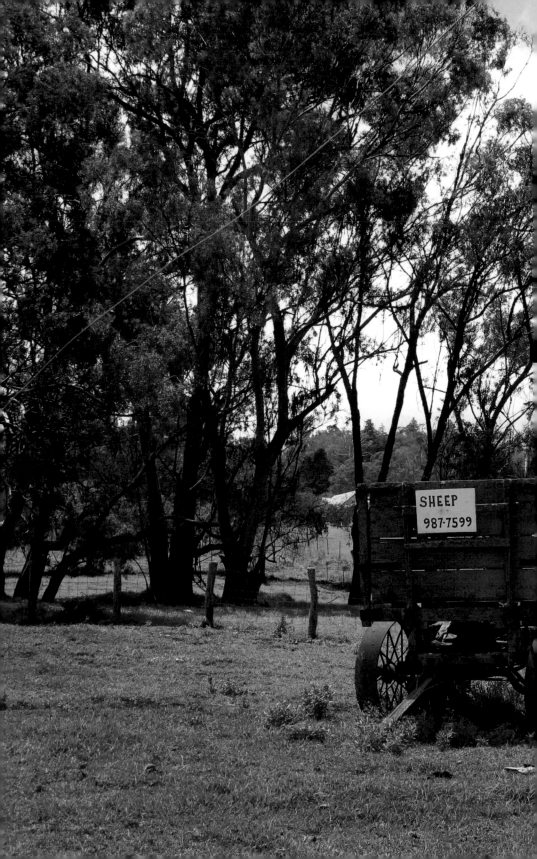

SHEEP
987-7599

Sugar-coated stir-fried chestnuts in Beijing, China

A street vendor serves "sugar stir-fried chestnuts" (糖炒栗子) from a cart in the Haidian District; these chestnuts are stirred in a hot wok filled with black gravel to distribute the heat evenly.

< Previous:

Green farmland in the center of the Big Island, Hawaii

A wooden wagon with a sign advertising sheep for sale, in the fields along Saddle Road in the center of the Big Island.

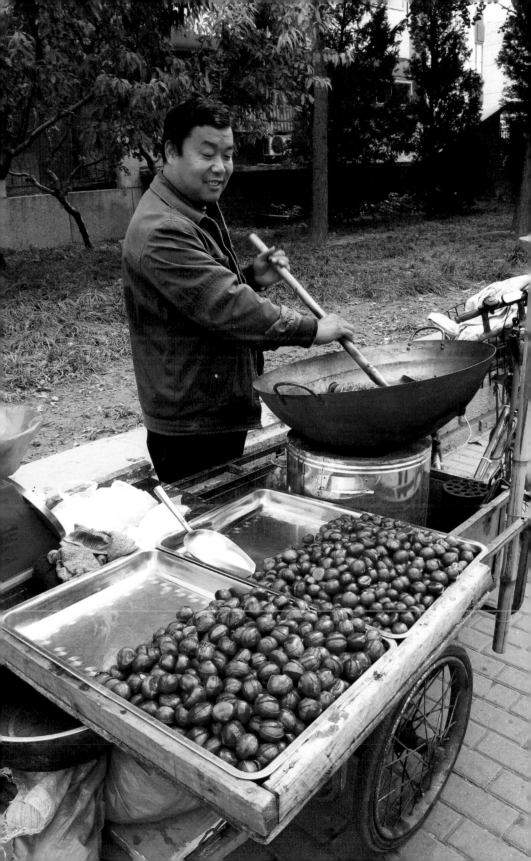

Rice flour steamed pork in Beijing, China

Fen zheng rou (粉蒸肉), spice-marinated pork belly steamed with a coating of rice flour as a thick, multi-textured sauce, served with purple-striped sweet potato steam buns.

Chinese long donuts in Shanhaiguan, China

A street vendor deep fries long breakfast donuts known as *youtiao* (油条) from freshly made dough in Shanhaiguan, Hebei Province, a popular breakfast item served with hot soy milk.

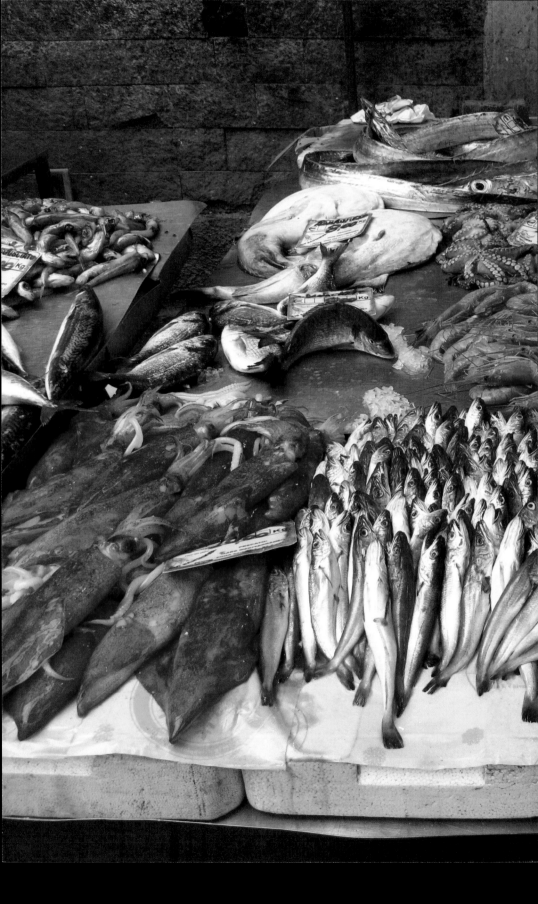

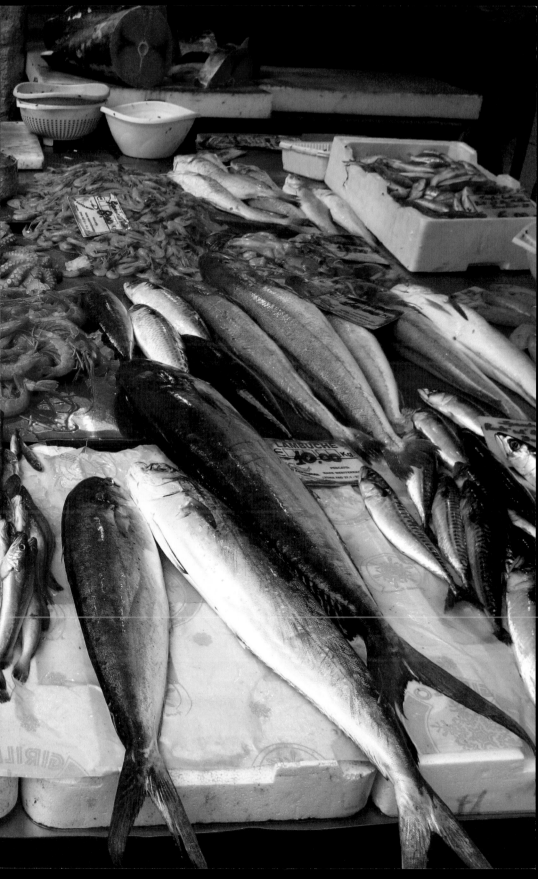

A lady street vendor in Mumbai (Bombay), India

A lady street vendor grills *makai* (मकई) or *bhutta* (भुट्टा), corn on the cob, on Elephanta Island off the coast of Mumbai.

< Previous:

Seafood on display at Ortigia Market in Siracusa, Sicily

Local fish, shrimp, squid and octopus at fishmonger Casa Del Pesce Santarosa of Ortigia Market in the old city.

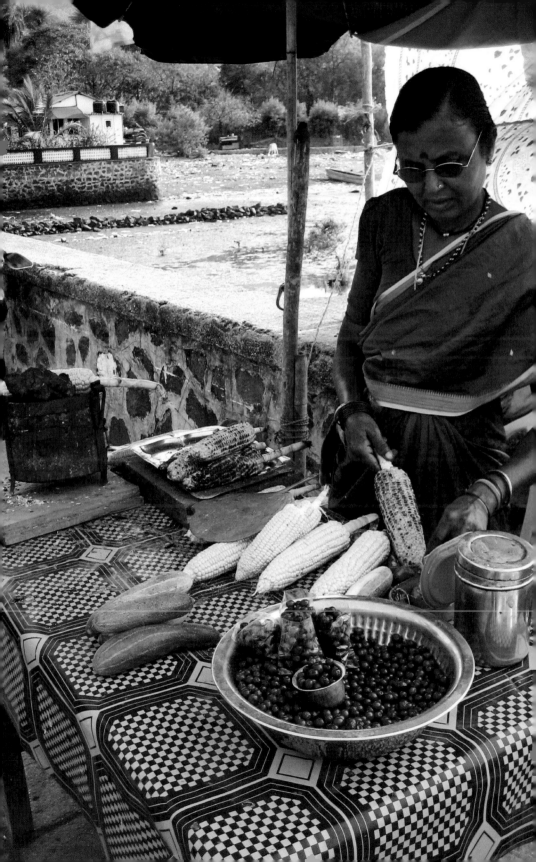

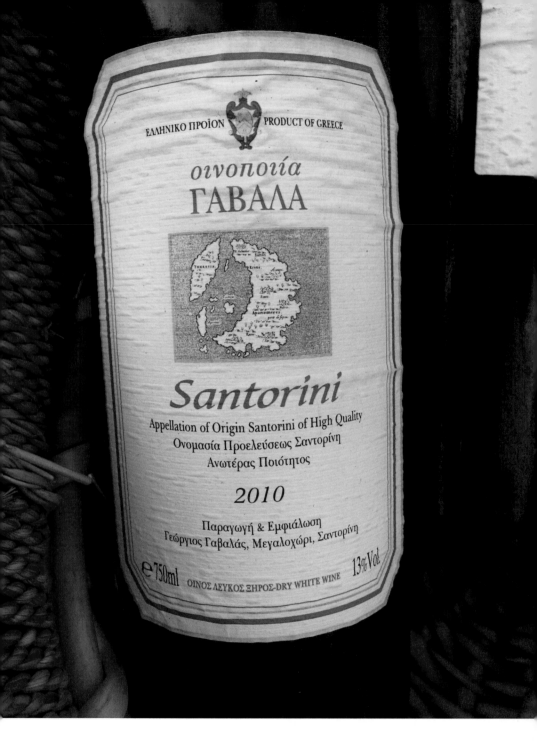

Local white wine in Santorini, Greece

Santorini (Σαντορίνη) white wine, produced from *Assyrtiko* and *Aidani* grapes grown in low basket-shaped vines on the island.

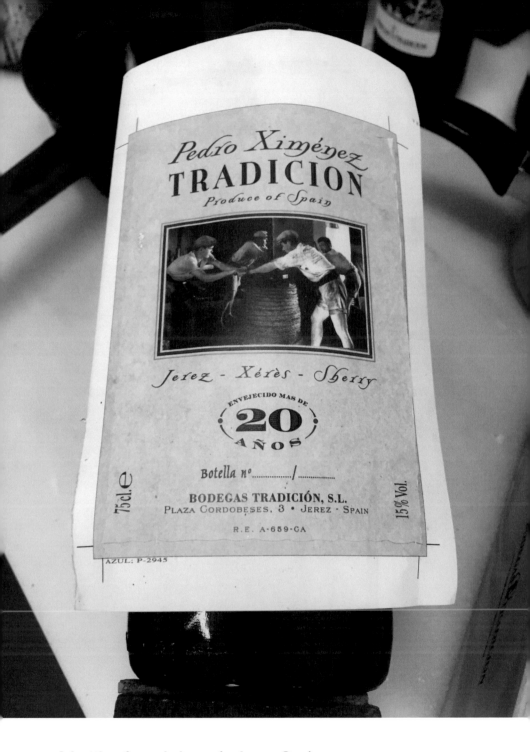

A bottle of aged sherry in Jerez, Spain

A label proof displayed in the bottling room, for the 20-year old sherry made from *Pedro Ximénez* grapes at Bodegas Tradición.

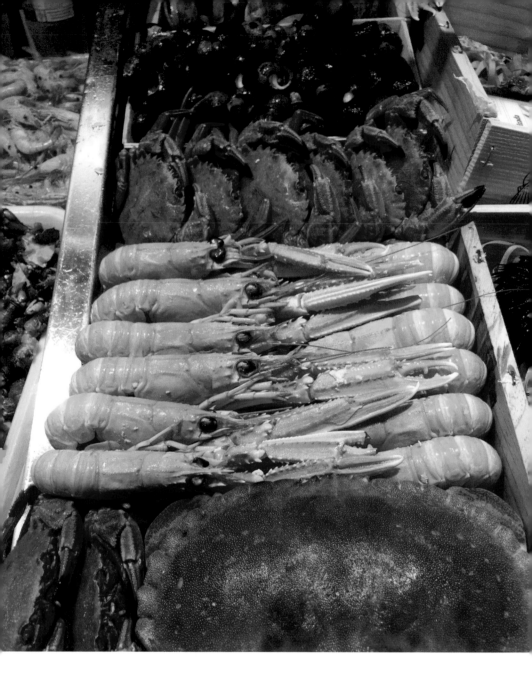

A variety of prepared seafood in Madrid, Spain

Langoustines (*cigalas*), crabs (*cangrejos*) and sea snails (*caracoles*) on display at Mercado de San Miguel.

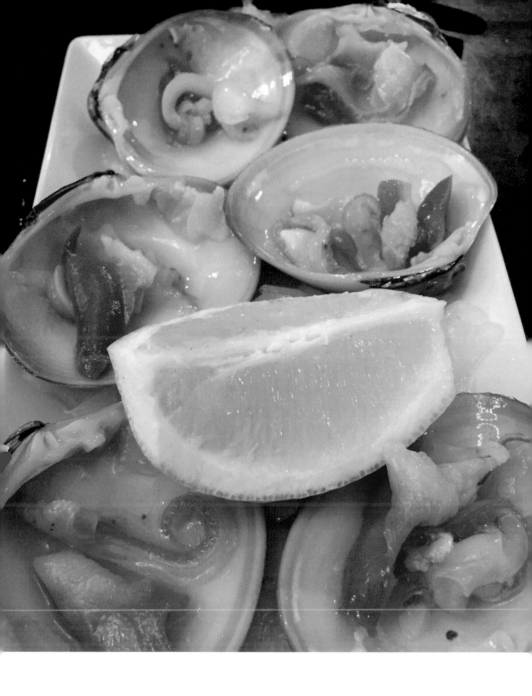

Fresh local clams, a specialty of Malaga, Spain

"Smooth clams" (*concha fina* or *callista chione*) at restaurant Marisqueria Canela Fina in Málaga, served raw with lemon.

Stacked bamboo steamer baskets in Beijing, China

Steamer baskets containing individual Tianjin-style steam buns (*bāozi* / 包子) at restaurant Goubuli Baozi (狗不理包子).

< Previous:

An Old Beijing-style snack street in Beijing, China

Huguosi Snack Street (護國寺街), a famous *hutong* lined with restaurants, including well-known Old Beijing establishments.

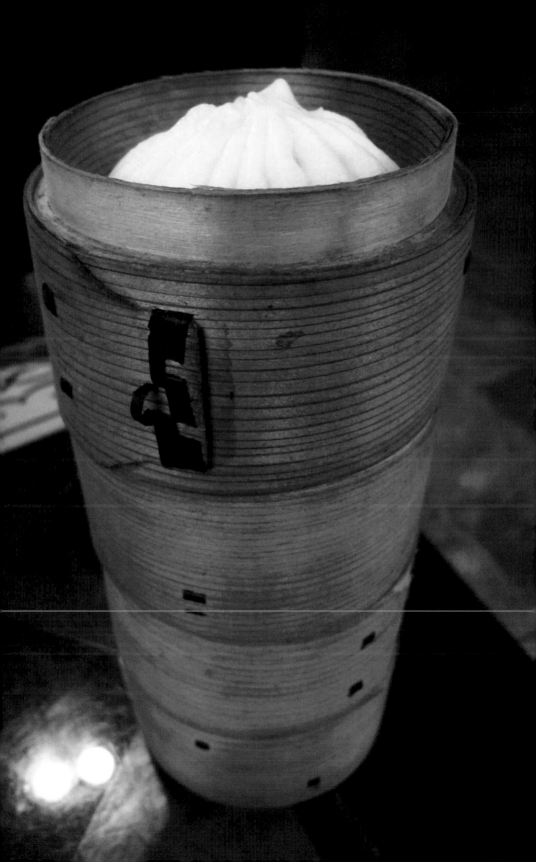

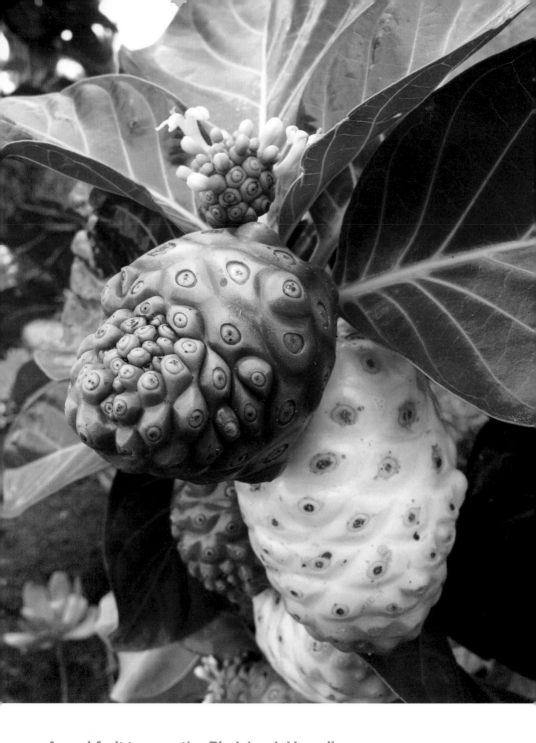

A noni fruit tree on the Big Island, Hawaii

Green, ripe and flowering *noni* fruit (*Morinda citrifoliain*) growing on a tree near Hōnaunau, known for its medicinal qualities.

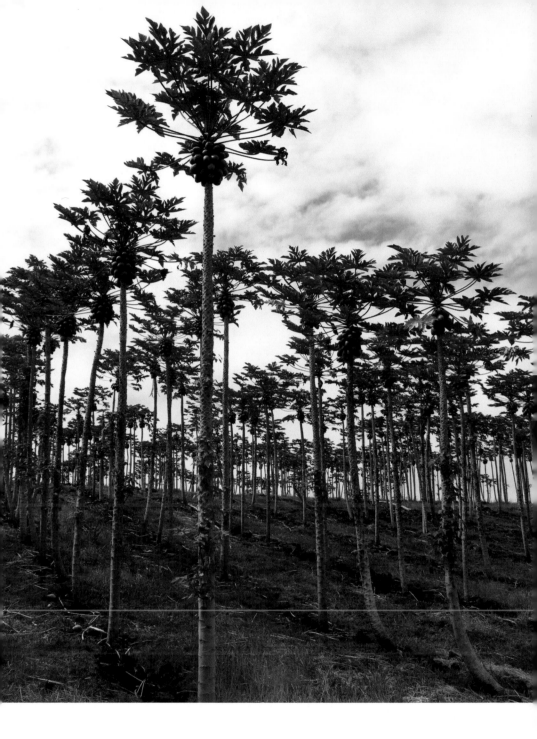

A papaya orchard on the Big Island, Hawaii

An orchard of papaya trees in neat rows off Highway 132 outside Pāhoa, heavy with fruit soon to be harvested.

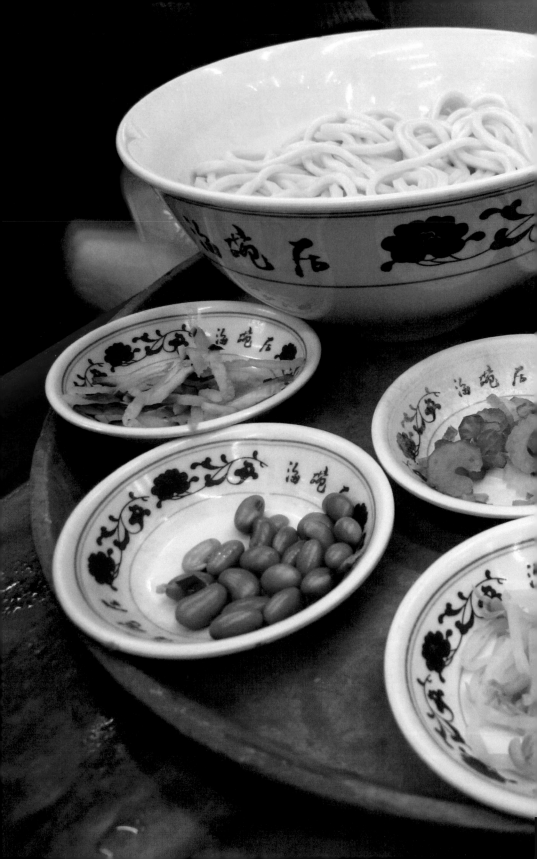

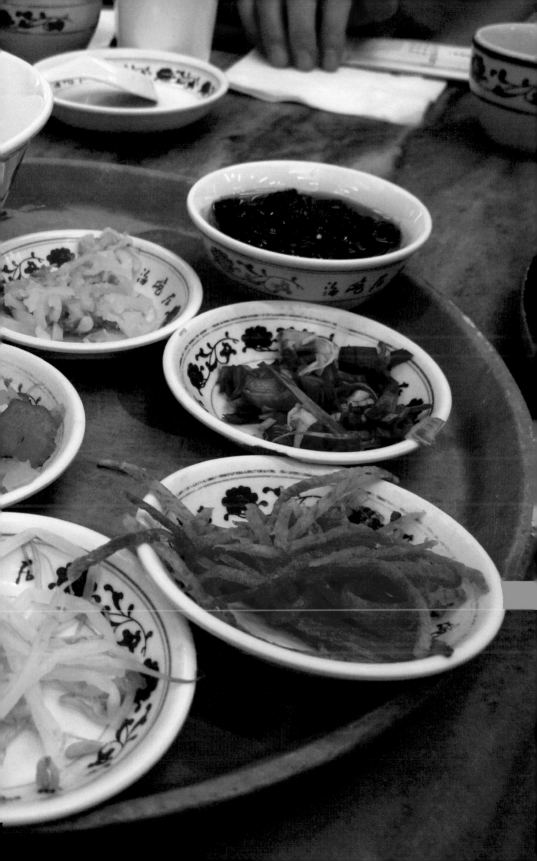

Rolled pork roast, a local specialty of Florence, Italy

A large *porchetta* sliced and served on your choice of bread at an *alimentari* (grocery), near Santa Maria Novella train station.

< Previous:

Old Beijing-style black bean sauce noodles in Beijing, China

Various ingredients to be mixed for *zhajiang mian* (炸酱面), a classic cold noodle dish with "black bean sauce" at restaurant Haiwan Old Beijing Zhajiangmian (海碗居老北京炸酱面).

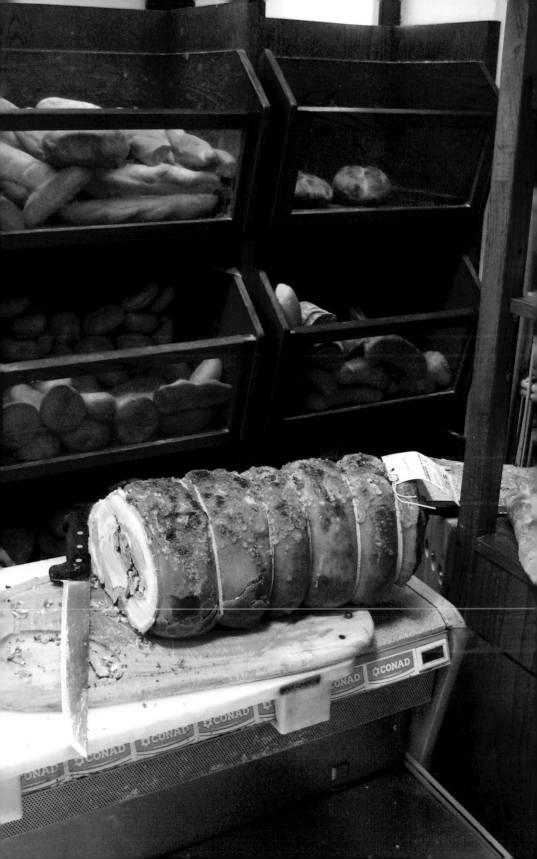

Sliced Iberian ham in Aracena, Spain

A plate of sliced *Jamón Ibérico de Bellota* (acorn-fed Iberian ham) produced in Aracena, served at Bar Casa Sirlache.

Cured French ham in Quebec City, Canada

Salt-cured aged ham (*jambon cru*) made locally by producer Les Cochons Tout Ronds at Marché du Vieux-Port (Old Port Market).

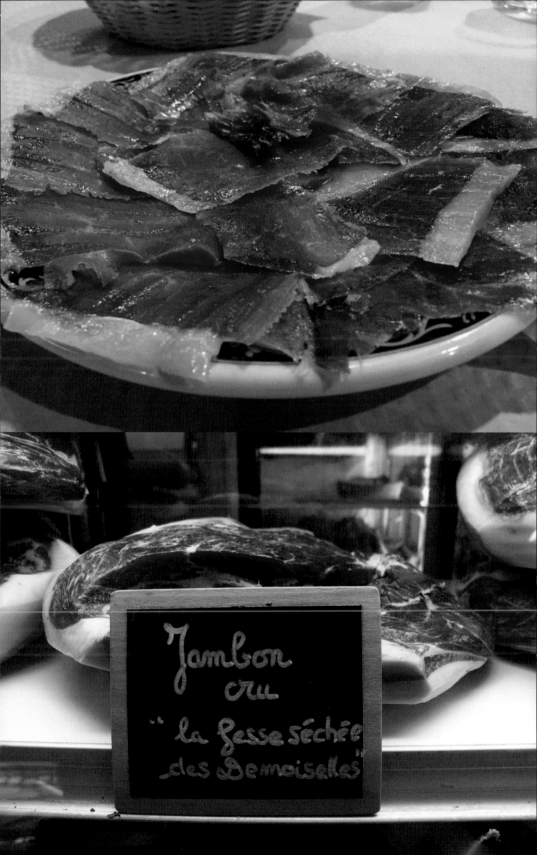

Jambon
cru
"la fesse séchée
des Demoiselles"

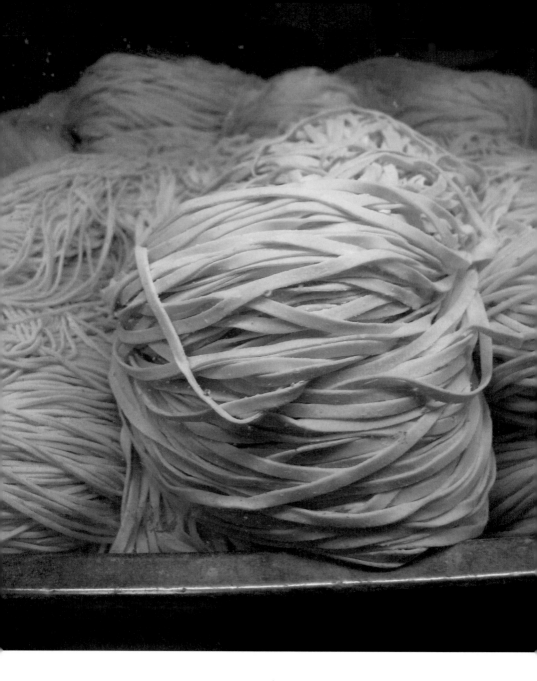

Bundles of fresh noodles in Beijing, China

Freshly made noodles (面条) of various thickness at Sanyuanli
Market (三源里市场) in the Chaoyang District. The market also
has numerous vendors selling fresh fish, meat and vegetables.

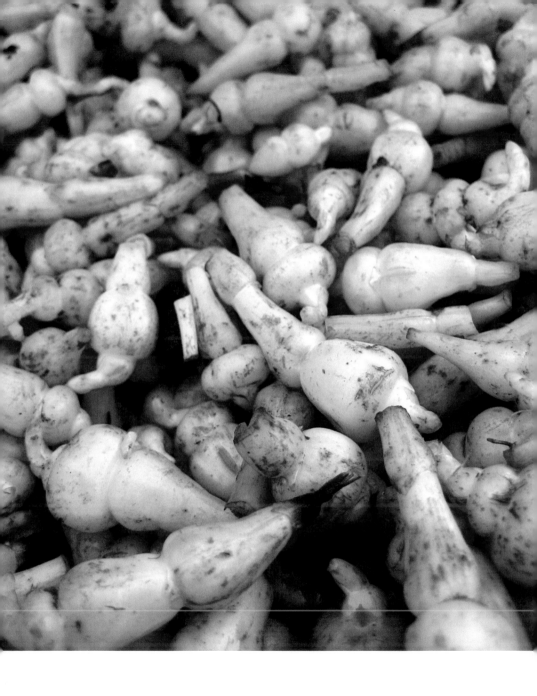

Chinese artichokes in Manhattan, New York

Crosnes (Stachys affinis), crunchy root vegetables also known as Chinese artichokes, similar to sunchokes, at the Mountain Sweet Berry Farm stand in Union Square Green Market.

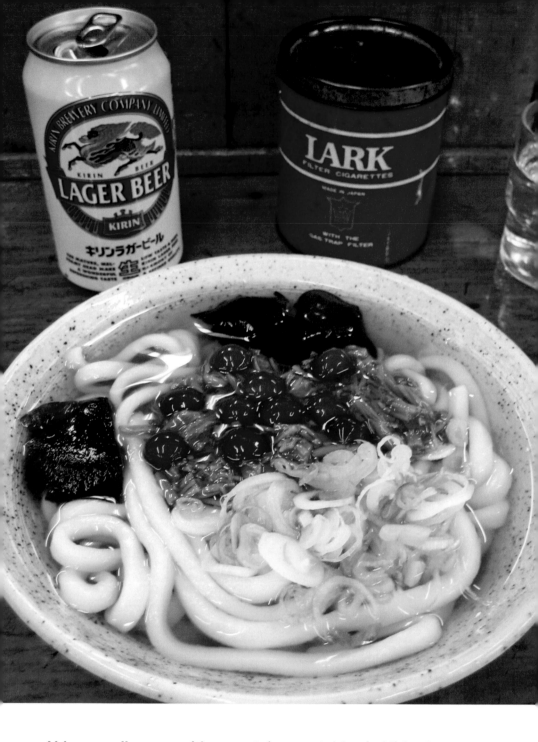

Udon noodle soup with mountain vegetables in Hida, Japan

Udon noodle soup topped with local wild mushrooms known as *nameko* (なめこ) and other mountain vegetables (*sansai* / 山菜).

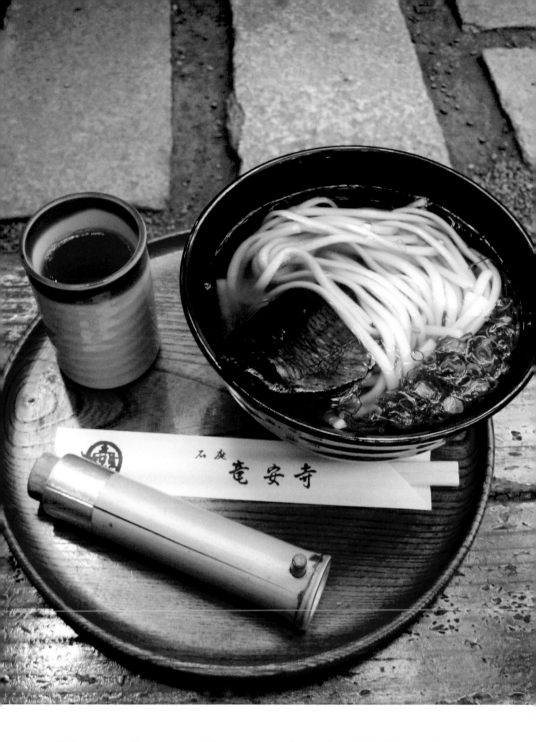

Udon noodle soup with preserved mackerel in Kyoto, Japan

Udon noodle soup with mackerel (*saba* or サバ); and a bamboo shaker of *shichimi togarashi* (七味唐辛子), a red pepper blend.

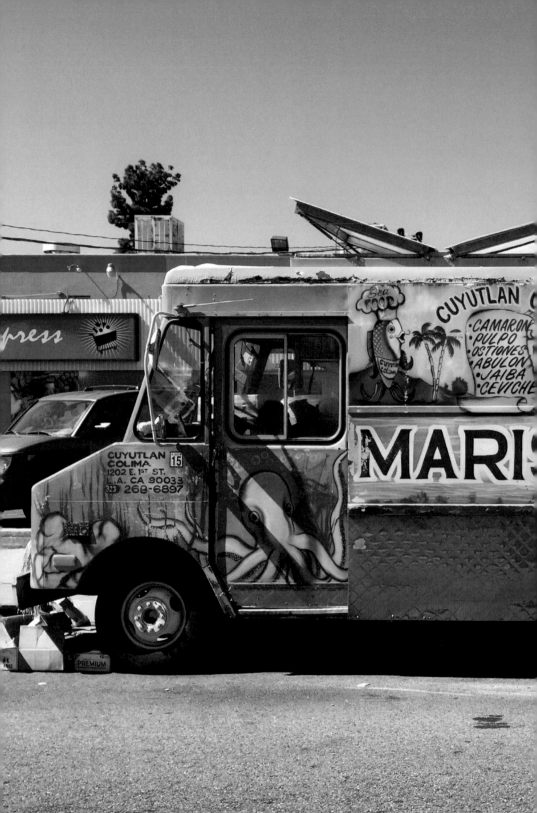

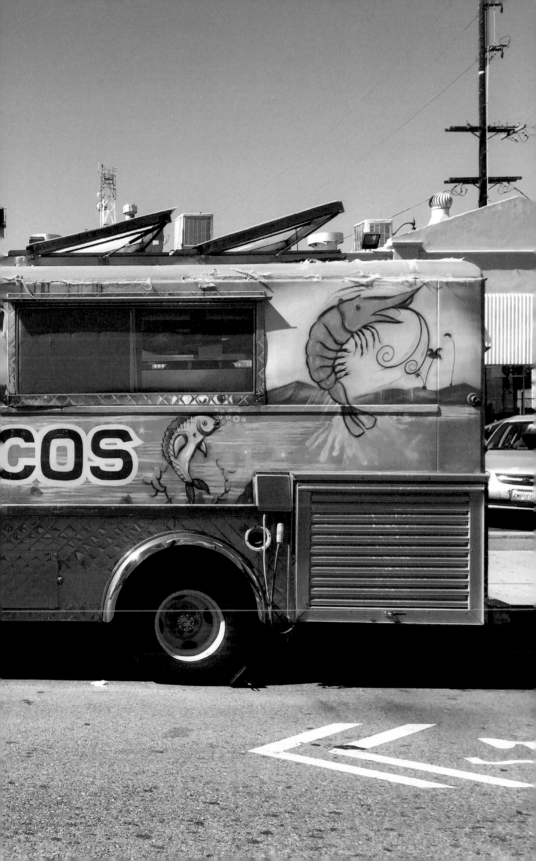

Swordfish and tuna at Ortigia Market in Siracusa, Sicily

Local swordfish (*pesce spada* or *pisci spata*) and tuna (*tonno* or *tunnu*) for sale at fishmonger Pescheria Fratelli Cappuccio.

< Previous:

A Mexican seafood taco truck in Los Angeles, California

Mariscos Cuyutlán Colima, a taco truck specializing in Mexican seafood has been roaming Boyle Heights for decades.

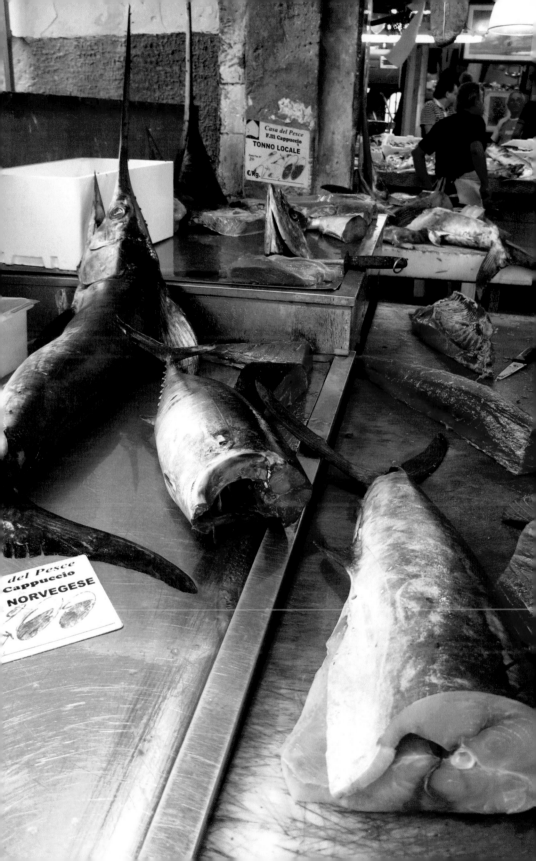

A local tavern in Cordoba, Spain

The bar inside Taberna Salinas, which specializes in local *Cordobés* dishes and wines from the Montilla-Moriles region.

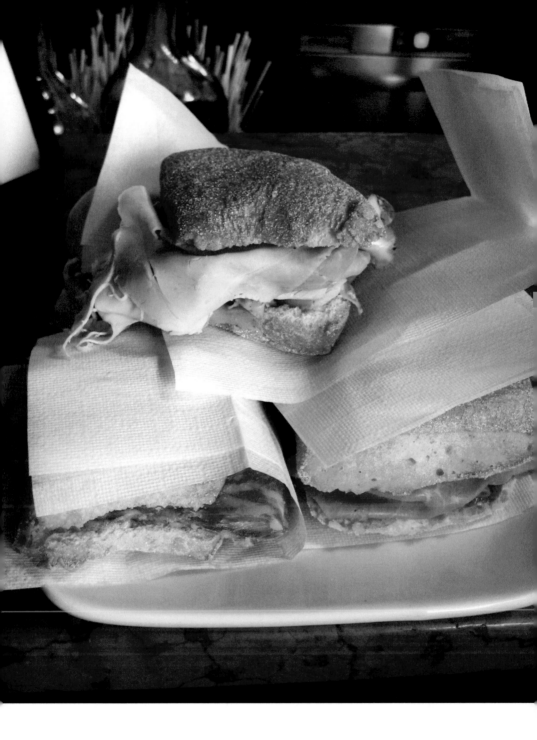

Panini with cured meats in Venice, Italy

Porca (pork), *sopressa* (a type of salami particular to Veneto) and *manzo* (beef) panini at Al Marcà, a local sandwich shop.

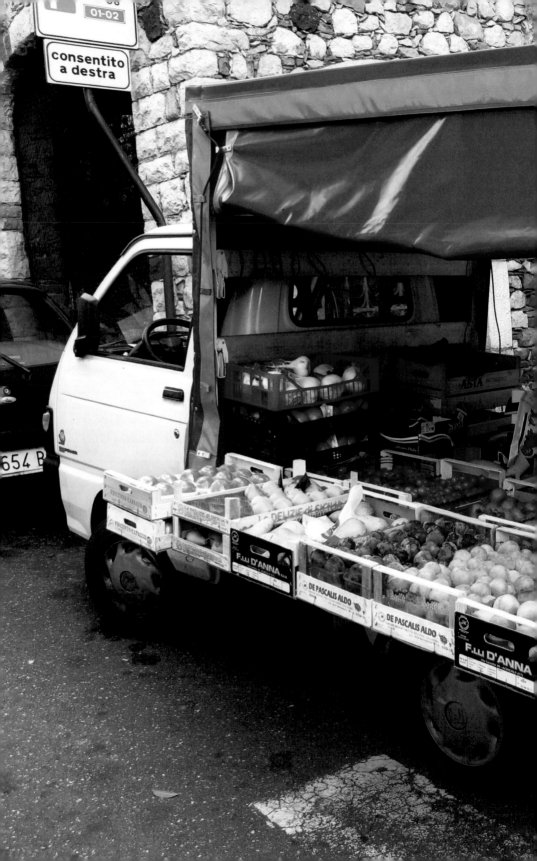

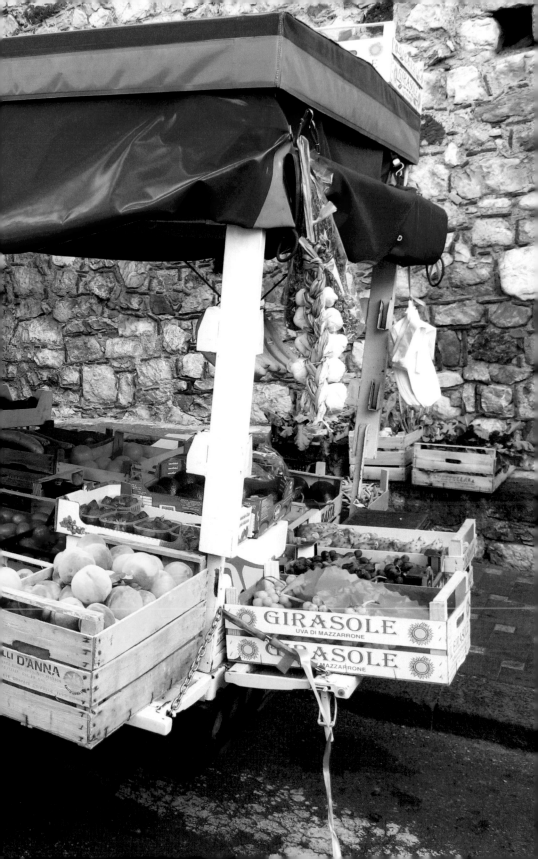

Classic Peking roast duck in Beijing, China

Slices of Peking / Beijing roast duck (北京烤鸭) at Bian Yi Fang (便宜坊), the oldest roast duck specialist in the country.

< Previous:

A colorful fruit truck in Taormina, Sicily

A vendor selling many kinds of fresh fruit from the back of a truck on the streets of Taormina in the Province of Messina.

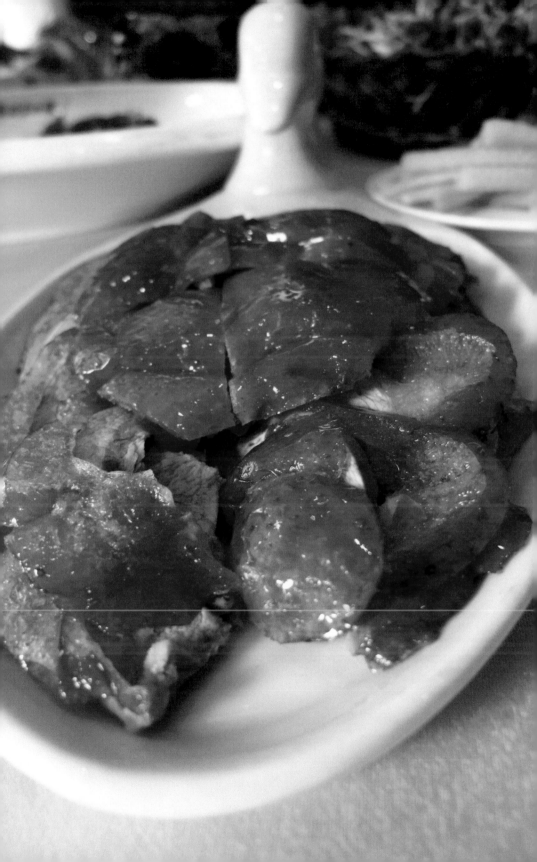

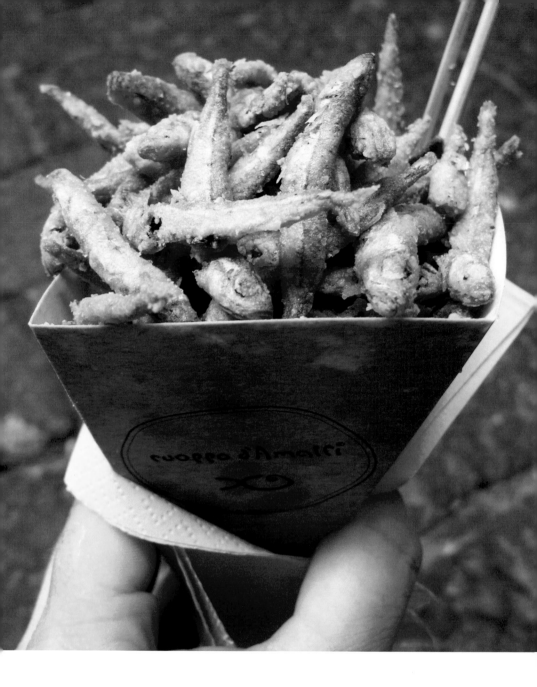

A paper cone of fried anchovies in Amalfi, Italy

A paper cone (*cuoppo*) filled with fried anchovies (*alici fritte*) at Cuoppo d'Amalfi, a local fried fish shop (*friggitoria*).

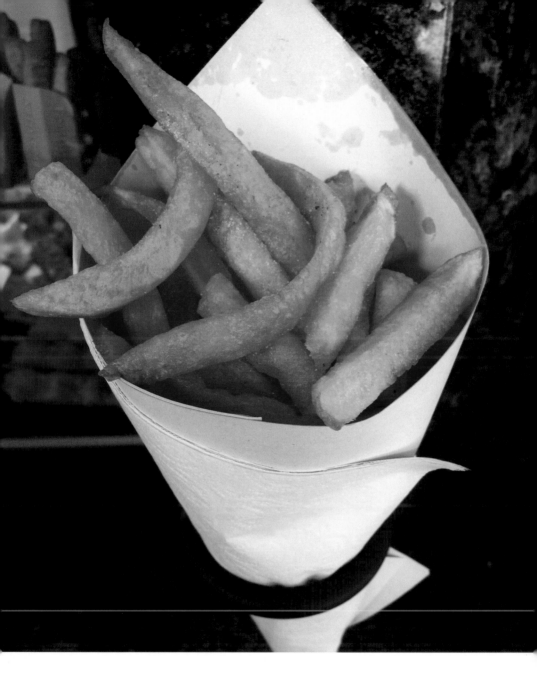

Fries in a paper cone in Brussels, Belgium

A paper cone of fries (*cornet à frites*) at Maison Antoine, a well-known *friterie* or *fritkot* (fry vendor) in Place Jourdan.

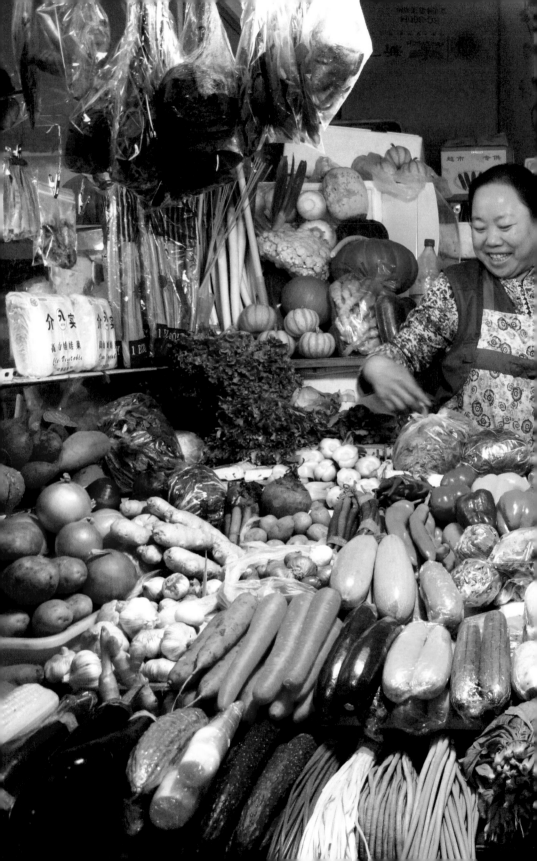

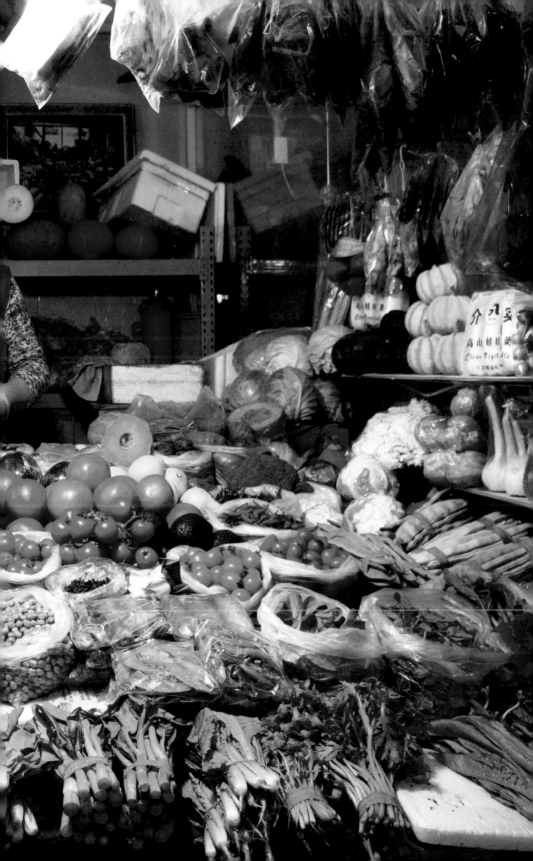

A sweet snack vendor in Kusadasi, Turkey

A street vendor selling *halka tatlısı*, syrup-soaked fried dough circles also known as *tulumba tatlısı*, similar to churros.

< Previous:

A vegetable vendor in Beijing, China

A lady vendor with a large selection of vegetables (蔬菜), both Chinese and Western, at Sanyuanli Market (三源里市场).

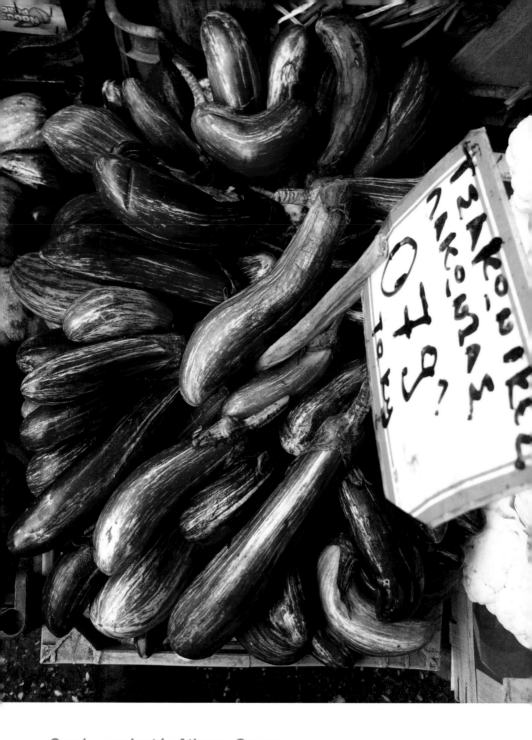

Greek eggplant in Athens, Greece

Striped *Tsakonian* eggplant (*melitzana* or μελιτζάνα) from the
Tsakonia region (τσακώνικη) at the Central Market.

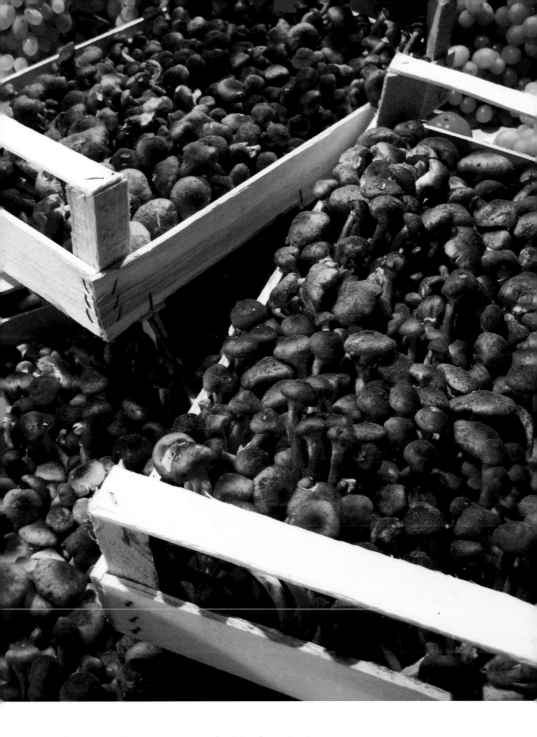

Crates of mushrooms in Venice, Italy

Chiodini mushrooms (*Armillariella mellea*) for sale at Rialto Market; the name roughly translates as "little nails."

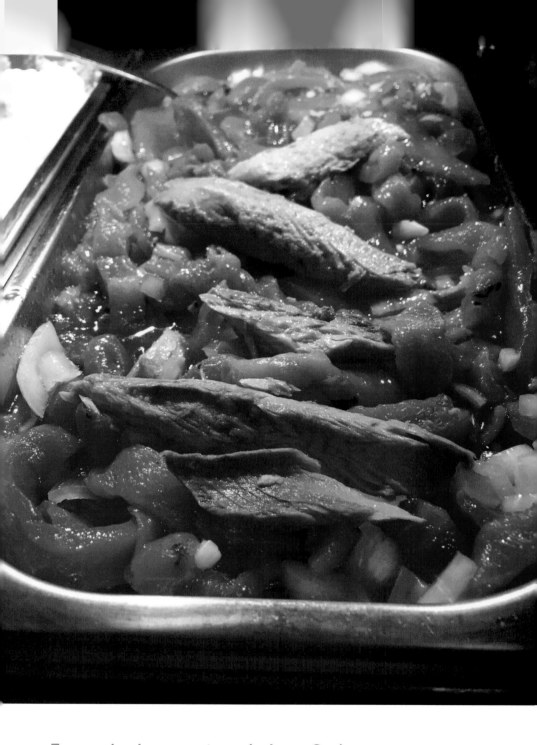

Tuna and red peppers tapas in Jerez, Spain

Atún con pimientos (tuna and sweet red *piquillo* peppers) ready to be served in small portions at a local tapas bar.

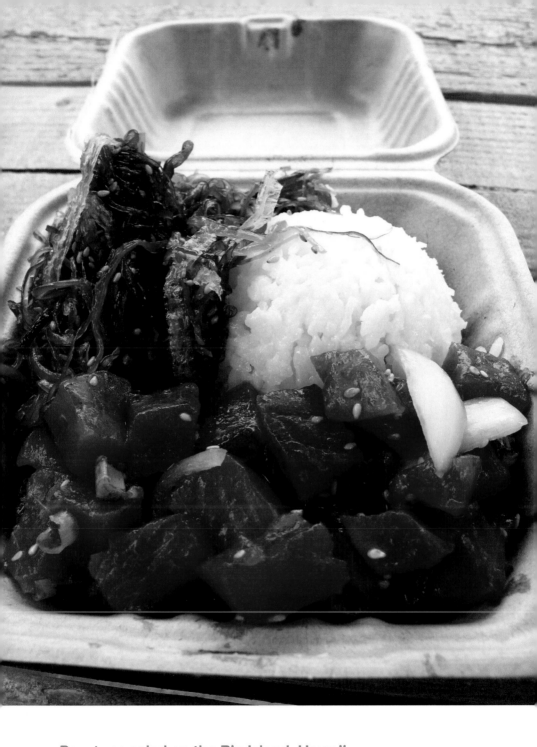

Raw tuna salad on the Big Island, Hawaii

A container of *ahi* (yellow fin tuna) *pokē* with sides of steamed rice and seaweed salad at Da Poke Shack in Kailua-Kona.

Street food vendors in Beijing, China

A line of street vendors near a metro station cook breakfast for commuters from wheeled carts with mobile griddles.

< Previous:

Classic Sichuan tofu in Beijing, China

Classic *mapo doufu* (麻婆豆腐) at Emei Restaurant (峨嵋酒家), the first Sichuan-style restaurant in Beijing, opened in 1950.

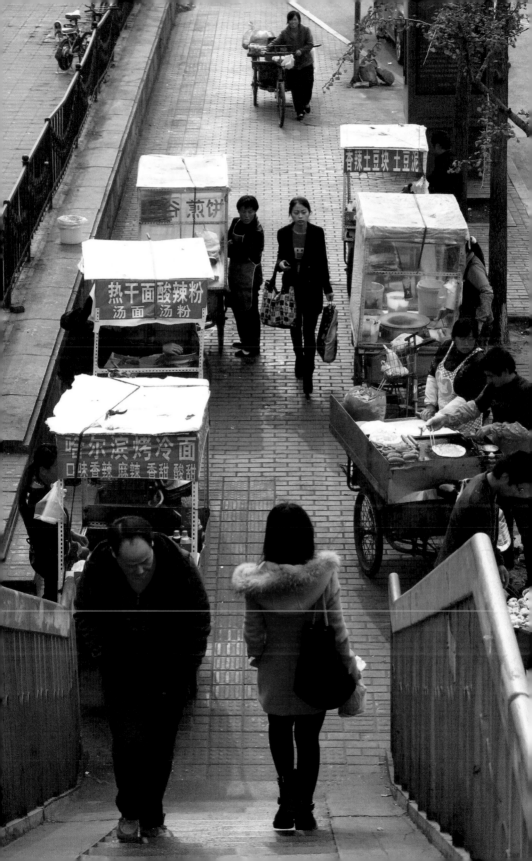

A wood burning pizza oven in Sorrento, Italy

A wood burning oven at a local pizzeria just lit for the day.

A brick bread oven in Kusadasi, Turkey

The oven and tools for baking the Turkish flatbread *lahmacun*.

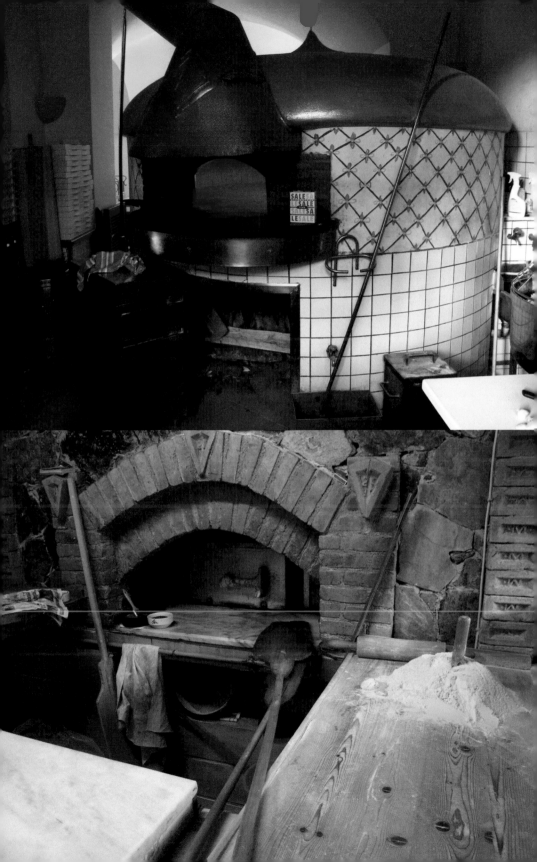

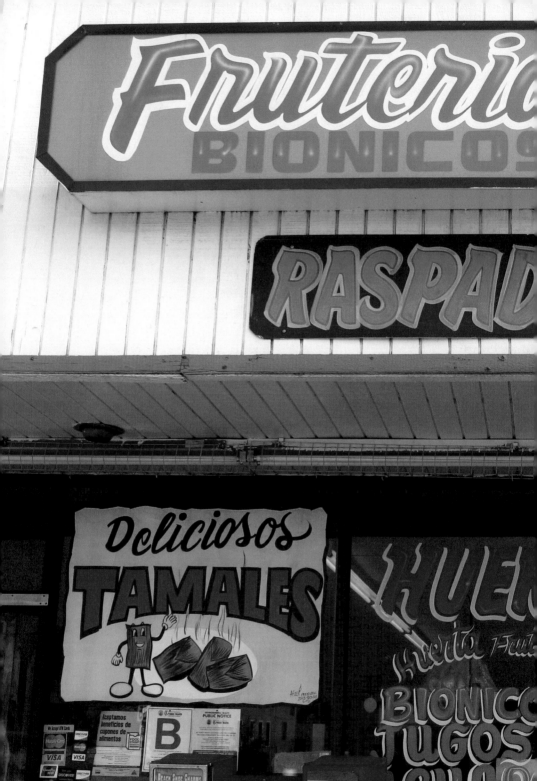

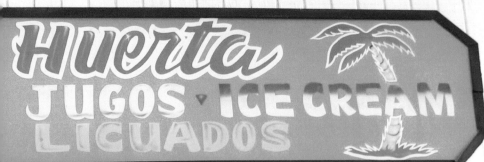

Huerta
JUGOS · ICE CREAM
LICUADOS

100% de... Fruta Natural

FRESH PROD

CHAMANGO
BIONICO RASPADOS COCTEL DE JUGOS
FRUTAS NATURALES

MELON COCO NARANJA
PASAS FRESA VAMPIRO
GRANOLA PIÑA ZANAHORIA
PLATANO CHICLE VITAMINICO
PAPAYA LIMON DE DIETA Y
MANZANA GUAYABA COLESTEROL
COCO RAYADO TAMARINDO
 VAINILLA

Crunch-Coffees

A plate of late night poutine in Montreal, Canada

Classic poutine, French fries (*frites*) topped with fresh cheese curds and brown gravy at restaurant Poutine La Banquise.

< Previous:

A Mexican fruit shop in Alhambra, California

Fruteria Huerta, specializing in *jugos* (juices), *licuados* (smoothies), *raspados* (snow cones), *helados* (ice creams) and *bionicos* (fruit salad with condensed milk and granola).

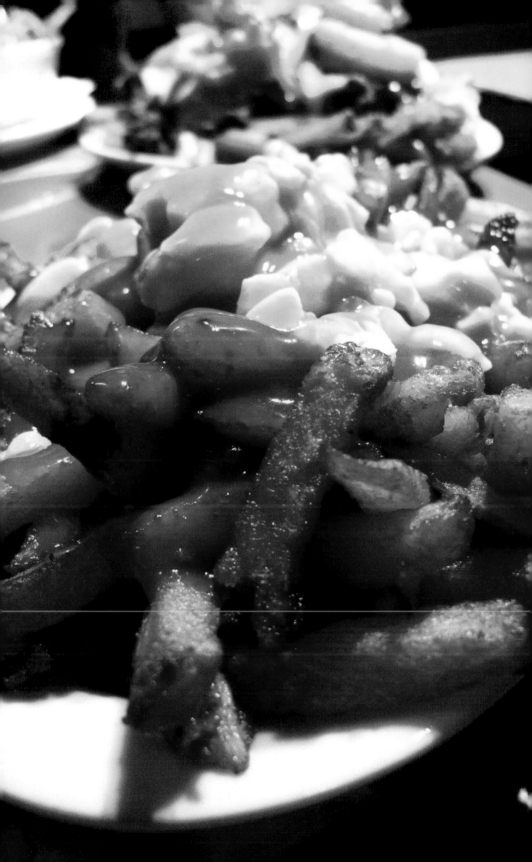

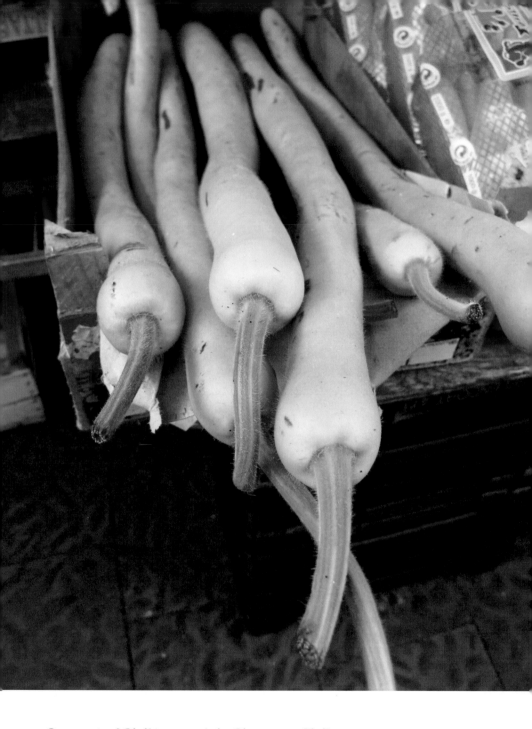

Serpent of Sicily squash in Siracusa, Sicily

A gourd known as *Zucchetta Serpente di Sicilia* (Serpent of
Sicily) or *cucuzzi* at Ortigia Market. A shorter form of this bottle
gourd or *calabash* is also used in Asian & Indian cuisines.

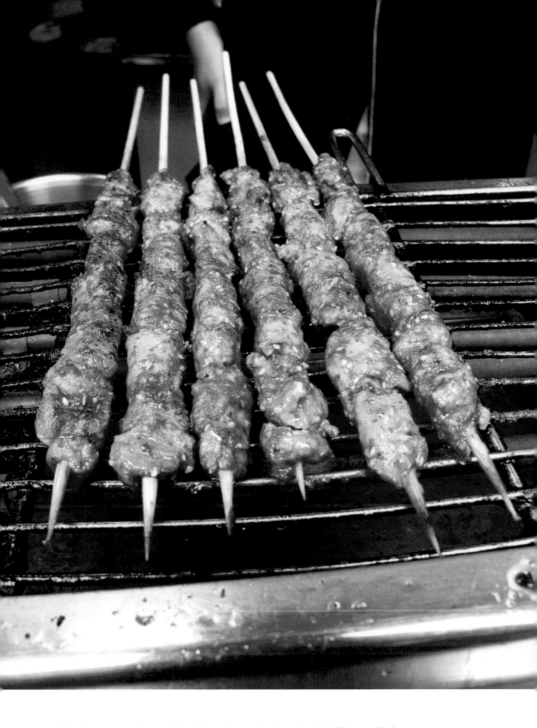

Xinjiang-style grilled lamb kebabs in Beijing, China

Halal grilled lamb on skewers (烤羊肉串) at Kao Rou Ji (烤肉季), a time-honored BBQ restaurant. These long kebabs are coated with cumin and chili powder, typical of Xinjiang Province.

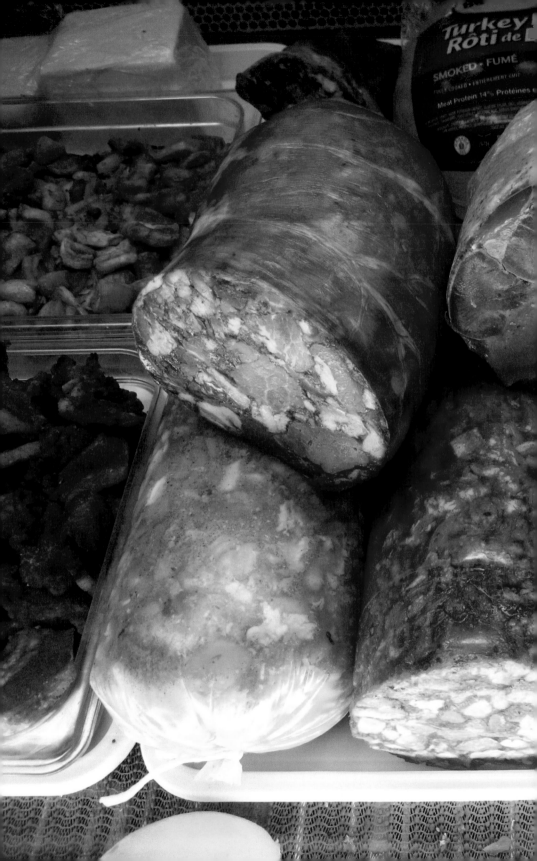

Traditional Turkish coffee in Kusadasi, Turkey

A cup of Turkish coffee (*kahve* or *Türk kahvesi*) at a small cafe in the old city, with a glass of water to cut the thick coffee.

< Previous:

French head cheese in Montreal, Canada

Fromage de tête or *tête fromagée* (head cheese) at Charcuterie Fairmount, a local butcher (*boucherie*) on Boulevard St-Laurent.

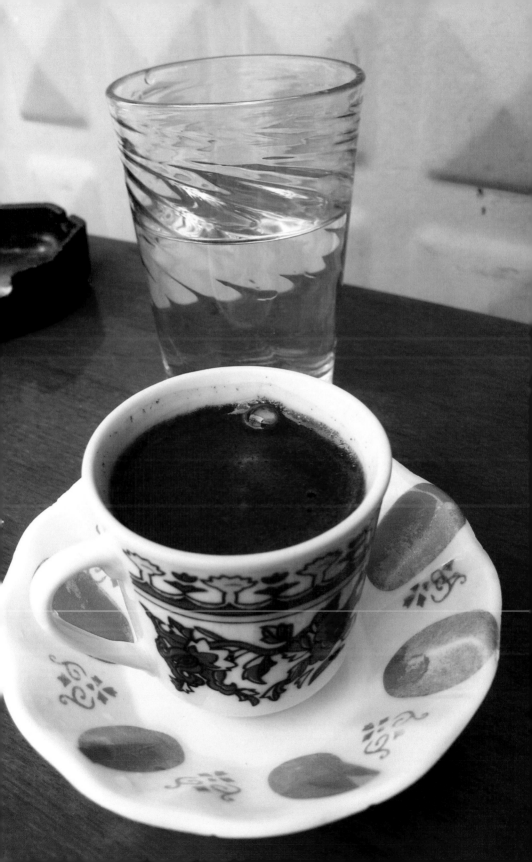

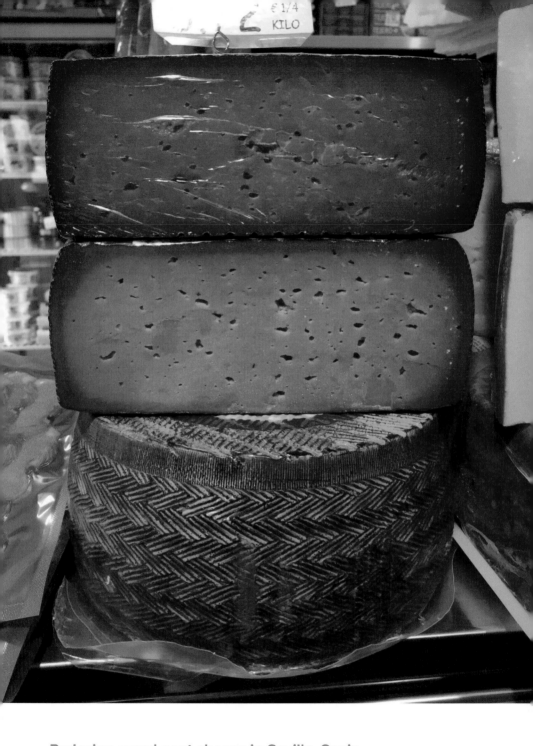

Red wine cured goat cheese in Seville, Spain

Queso de cabra manchego curado con vino tinto (goat cheese cured in red wine) at Mercado de Triana, a market in Sevilla.

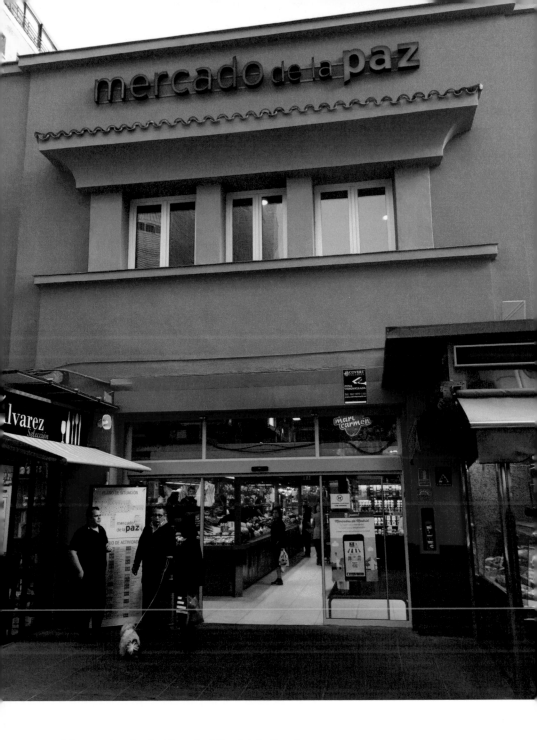

Mercado de la Paz in Madrid, Spain

Mercado de la Paz, a market home to many *charcuterías* (delis), *pescaderías* (fishmongers) and *carnicerías* (butchers).

A steam bun shop in Beijing, China

A tiny shop selling Northern-style steam buns (*baozi* / 包子).

< Previous:

Chinese-Islamic street food in Beijing, China

A vendor selling Chinese-Islamic halal (清真菜) snacks; the Chinese characters on the cart translate as "Muslim" (穆斯林).

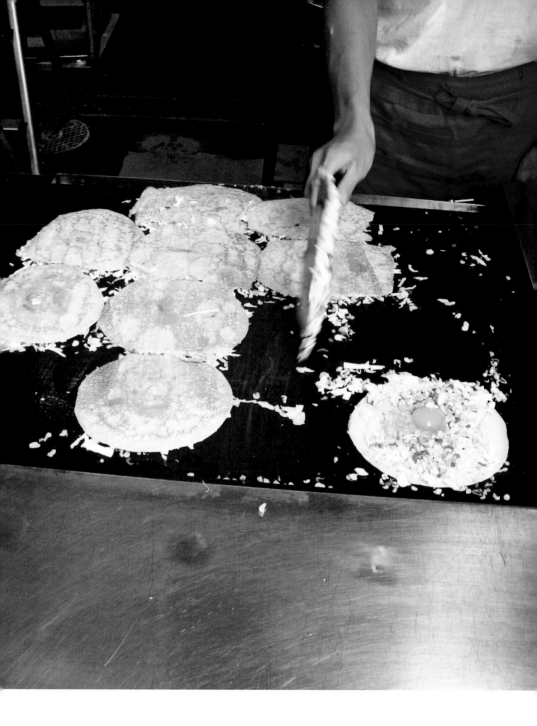

A savory pancake vendor in Osaka, Japan

A vendor flipping Osaka-style *okonomiyaki* (お好み焼き), a type of Japanese savory pancake with many variations, outside the local food market known as Kuromon Ichiba (黒門市場).

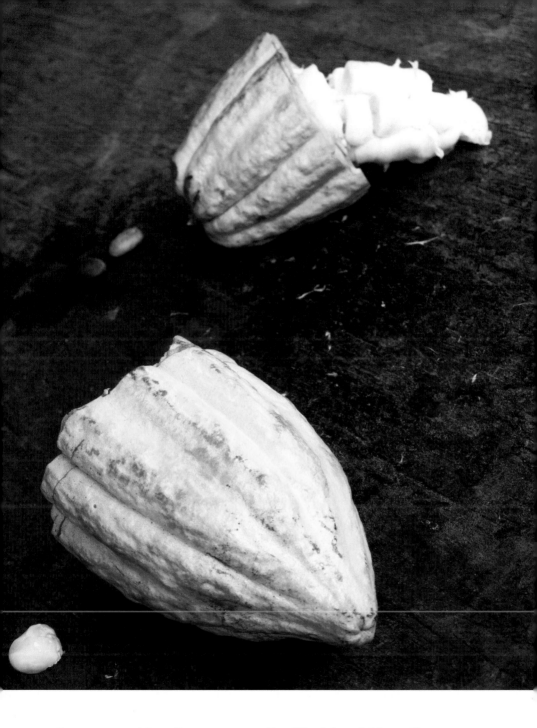

A cacao pod locally grown on the Big Island, Hawaii

A ripe cacao pod split open to reveal the beans at Original Hawaiian Chocolate in Kailua-Kona, a producer of local chocolate from the *Criollo* and *Forastero* varieties of cacao.

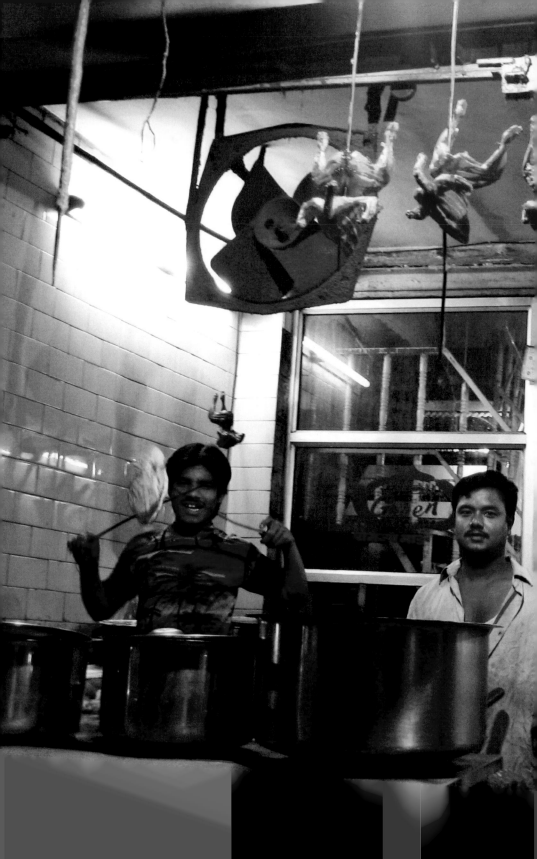

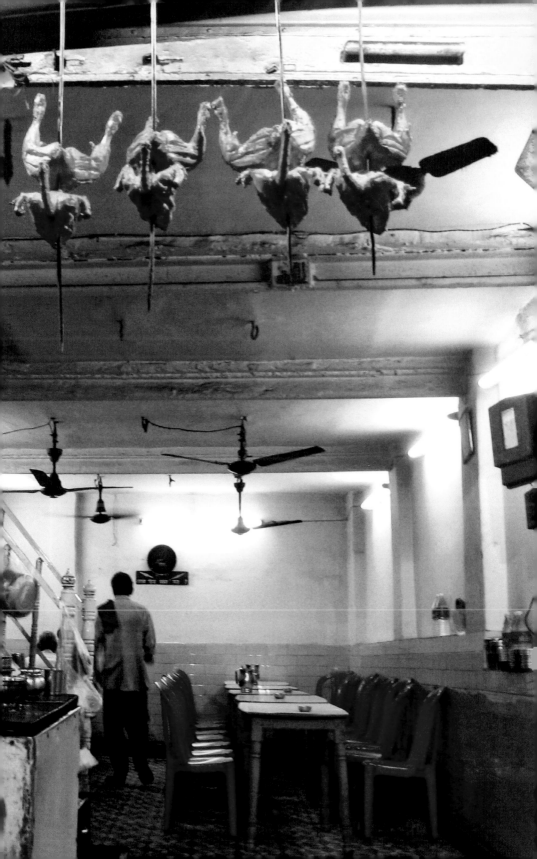

Traditional gyros in Athens, Greece

Large rounds of gyros (Γύρος) meat cooking on the rotating vertical spits at a small gyro shop, ready to be sliced.

< Previous:

Tandoori chicken in Jaipur, India

Whole chickens roasted in a tandoori oven (तंदूर), hanging from spikes at a restaurant specializing in tandoori chicken.

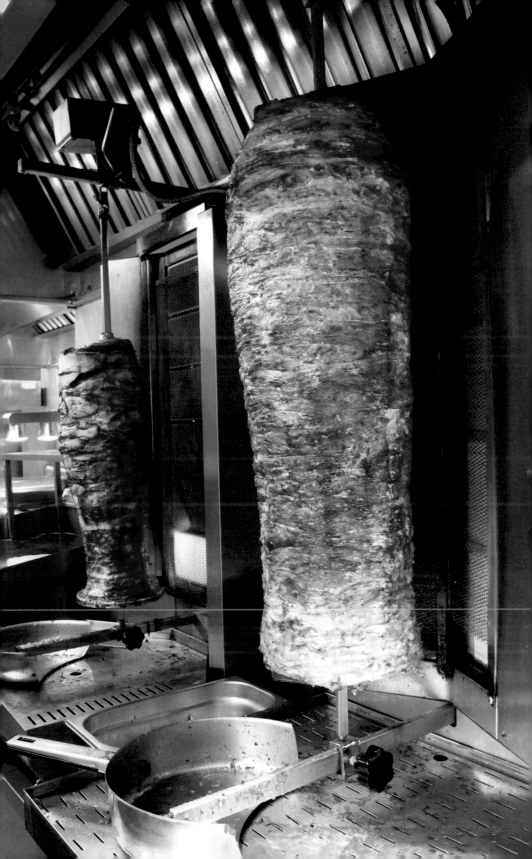

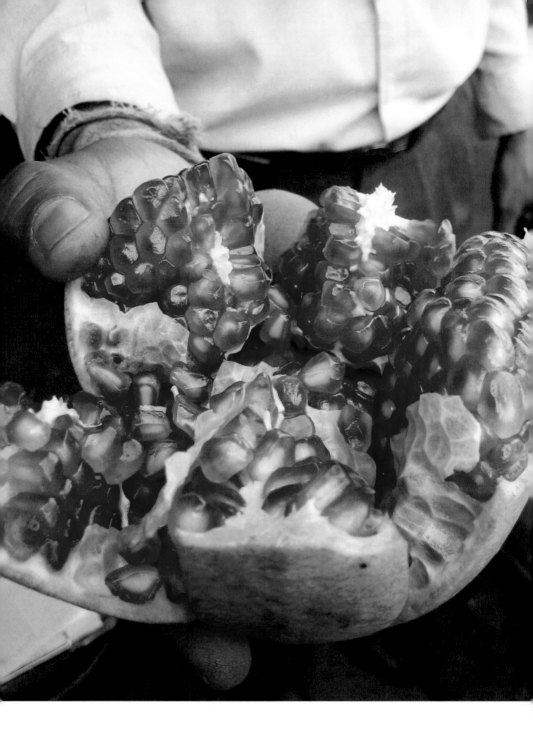

A large pomegranate in Udaipur, India

A chef holding a pomegranate (*anar* or अनार) at the city market,

Fresh cranberry beans in Rome, Italy

Borlotti beans at the Piazza San Cosimato market in Trastevere.

Old Beijing-style snacks in Beijing, China

A tiny stall selling Old Beijing specialty snacks (老北京特色小吃) on the backstreets of Qianmen (前门).

The list includes

- *Lu dagun* (驴打滚), glutinous rice rolls with bean paste.

- *Tang erduo* (糖耳朵), "ear shaped" honey bread twists.

- *Tangmi guo* (糖蜜果), sugar coated dried fruit.

- *Dousha bing* (豆沙饼), red bean pancakes.

- *Baitang bing* (白糖饼), white sugar pancakes.

- *Xiansu bing* (咸酥饼), crispy salty biscuits.

- *Jidan bing* (鸡蛋饼), thick egg pancakes.

- *Zhima bing* (芝麻饼), sesame biscuits.

- *Guazi su* (瓜籽酥), melon seed brittle.

- *Cha jidan* (茶鸡蛋), tea eggs.

- *Da bing* (大饼), big flour pancakes.

- *Da mahua* (大麻花), big bread twists.

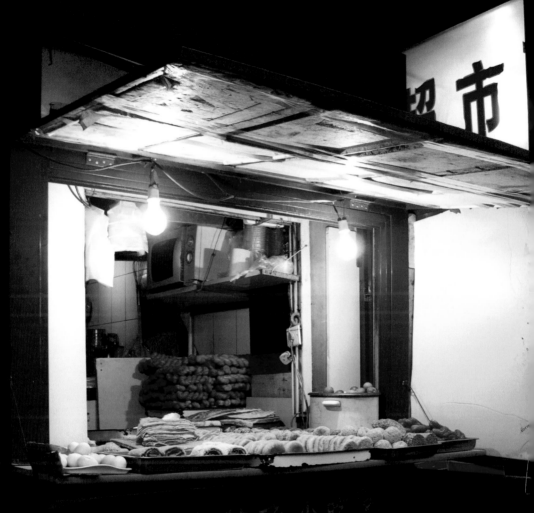

超市

清真 老北京特色小吃

驴糖糖豆白咸鸡芝瓜茶
打耳蜜沙糖酥蛋麻籽鸡
滚朵果饼饼饼饼饼酥蛋
　　　大饼　大麻花

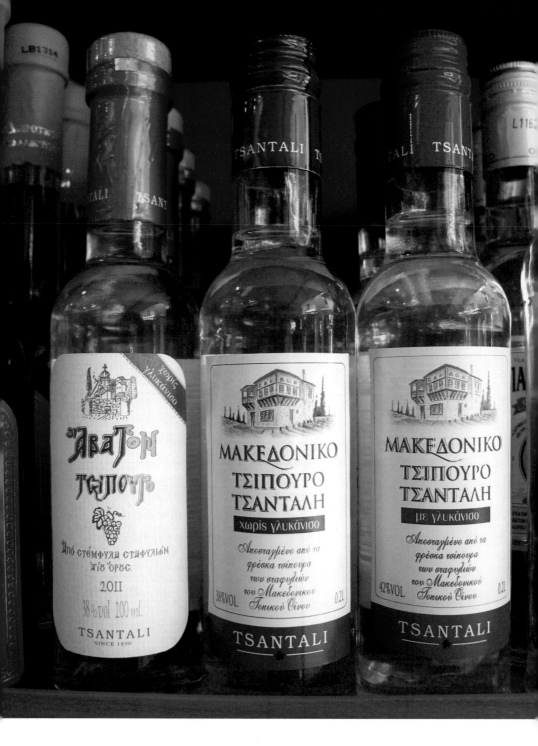

Traditional Greek pomace brandy in Athens, Greece

Three varieties of Greek pomace brandy *Tsipouro* (Τσίπουρο), from the left: *Agioritiko* (Mount Athos), with anise, and without.

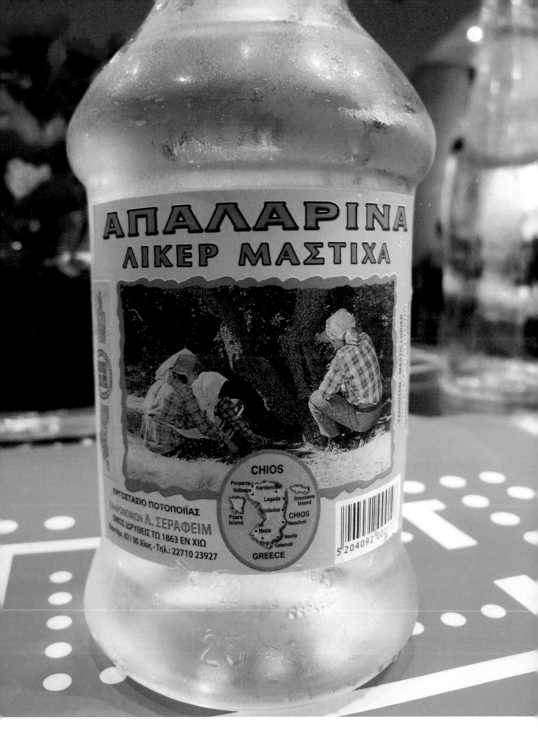

A liquor made from mastic tree resin in Athens, Greece

Apalarina (ΑΠΑΛΑΡΙΝΑ) *masticha* liquor (ΛΙΚΕΡ ΜΑΣΤΙΧΑ) from the island of Chios, the origin of the mastic tree resin.

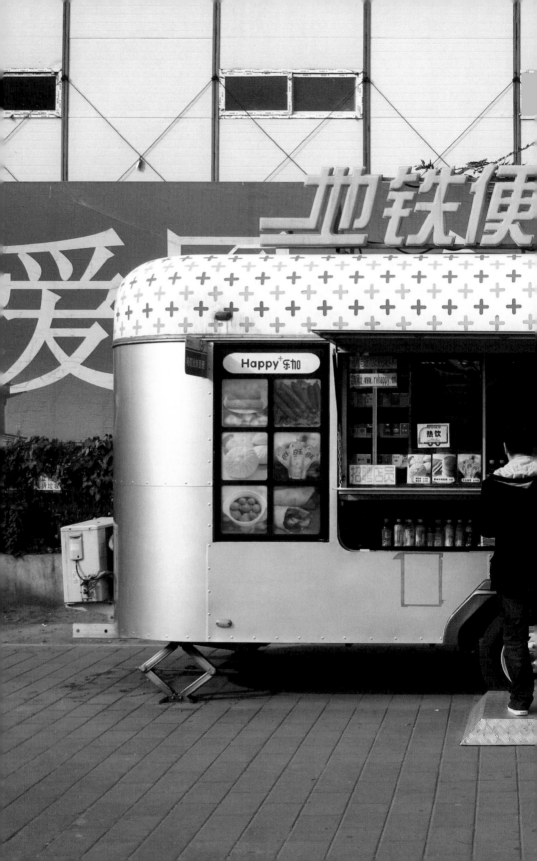

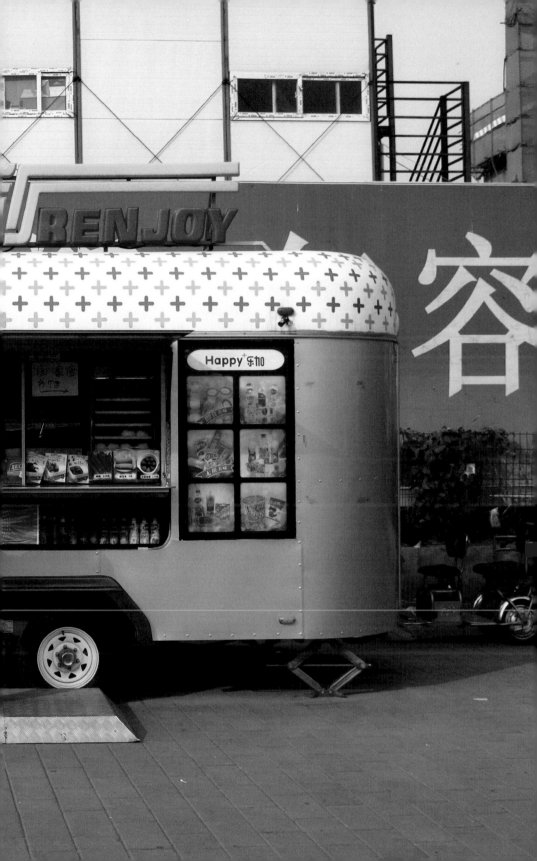

A kitchen shop in Old Delhi, India

Kadhai (कढ़ाई) and *tawa* (तवा) pans, as well as various other kitchenwares for sale at Bharat Iron Store. *Kadhai* are similar to Chinese woks; *tawa* are flat pans for making *roti* (flatbread).

< Previous:

A mobile RV convenience store in Beijing, China

Renjoy (地铁便利), a convenience store housed in an RV, carries snacks such as *congee* (粥), fresh soy milk (豆浆), coconut corn cake (玉米椰香饼), and Taiwanese sausages (台湾烤肠).

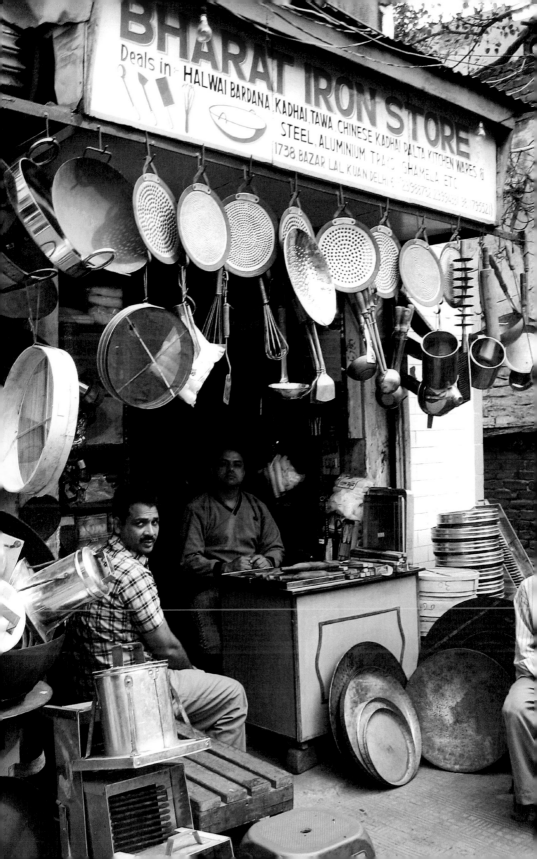

A variety of "mouth fresheners" in Ahmedabad, India

A street vendor sets up a stand with a variety of sweet and savory Gujarati "mouth fresheners" (*mukhwas* or મુખવાસ).

Last: >

The butcher section at the Central Market in Athens, Greece

One of several aisles of butchers' stalls at the Central Market, offering every cut of meat imaginable, nothing wasted.

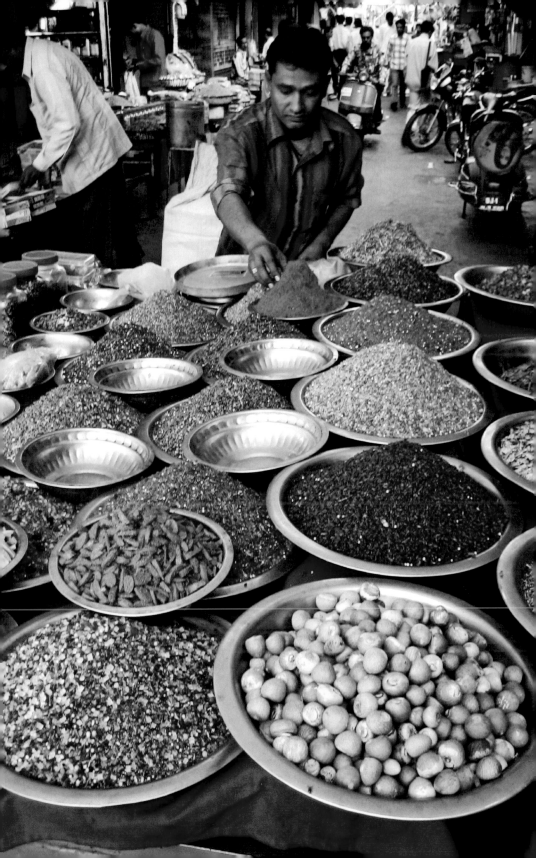

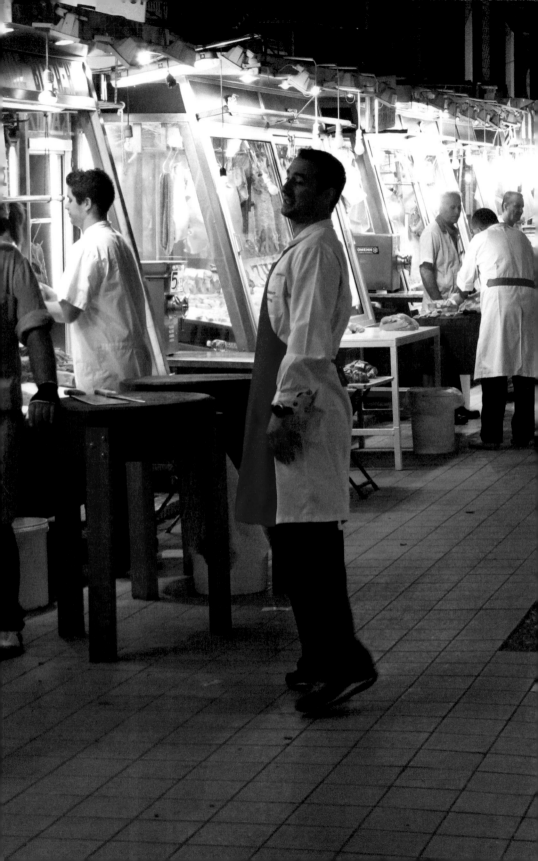

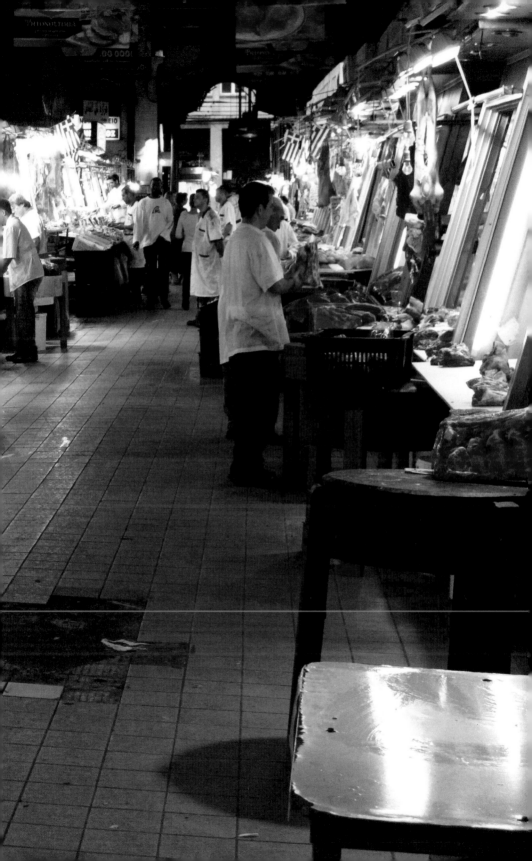

Lightning Source UK Ltd.
Milton Keynes UK
UKRC010618300519
343570UK00009B/210